The Southwest Canvases of Louis Akin

COLOR AND LIGHT

The Southwest Canvases of Louis Akin

BY BRUCE E. BABBITT

Northland Press

Contents

Illustrations

Foreword

FOR YEARS I HAD KICKED around the putting together of a book on the artist Louis Akin but never took any overt steps. So, when young Bruce Babbitt showed up with a manuscript on Akin, I read it with a great deal of curiosity and interest. I was impressed with the depth of research Bruce had done, and it certainly brought back some memories of my growing up in Flagstaff, where Akin also spent a good part of his life.

Bruce asked me to do the foreword for this book, and I tried to summon what memories I had of Akin. Since I was just a pup at the time, I cannot remember Akin distinctly as a person, but he did collaborate with me on my first business venture. This took place in Flagstaff during the last summer of his life. He was forty-four and I was six. The business was a lemonade stand, and according to my mother, he had painted the sign for it. Pictures in the family album show me standing before my emporium, nattily attired in a Buster Brown suit, but unfortunately the sign is not visible.

While I was growing up, several of his paintings hung in our house on North Fort Valley Road somewhat south of the Museum of Northern Arizona, and I admired them greatly. Tragically, these were destroyed when the original Lockett house burned to the ground. It was later rebuilt on the original foundations. The firemen, not realizing the paintings were our prized possessions, devoted all their attention to saving the old oak dining room table instead. However, when my mother, Hattie Greene Lockett, died, we found among her personal effects reproductions of Akin illustrations. These were sporting scenes, probably typical of those he did for outdoor life magazines while in New York.

Around 1910 or 1911, he asked my father, Hank Lockett, to sell him the land across the road from our Flagstaff summer home. He agreed, and this was the land on which Akin built the large house, following his marriage. At any rate, he was a friend of

the family and came to see us often during the latter years of his life. My family talked about him a great deal — how he went to live with the Indians, his paintings of them, and his untimely death.

From hearing these stories and from looking at his paintings, I began to admire Louis Akin personally and wanted very much to be like him. Subsequently, when I went to college, I concentrated on Indian and art subjects. I didn't pursue an art career, but I did work for a number of years among the Indians. As the years passed, I would often see Akin's art in Flagstaff homes — a painting or one of his famous prints, such as *In Oraibi Plaza* or *El Tovar Hotel*, but never have I found one in an art gallery.

The publication of this book will introduce Louis Akin to a much broader segment of the public. It is a belated, but well-deserved recognition for one of the first serious artists to live in Arizona, as well as a reminder that much of the history on Southwestern art and artists remains to be discovered. It is fitting, too, that Louis Akin should be introduced by Flagstaff people. Some of his most productive years were spent here and local residents, particularly the Babbitt family, were his staunchest patrons.

Clay Lockett

Preface

A FADED SNAPSHOT taken in 1904 shows Louis Akin with long hair and moccasins, wrapped in a Hopi blanket, posed outside his pueblo dwelling in old Oraibi. Another surviving picture, a sepia portrait taken a year or two later by Karl Moon, records him perched on the edge of the Grand Canyon working on a landscape.

These two old photographs symbolize much of Akin's life in the Southwest. The Hopi snapshot suggests him as a romantic, environmentalist, lover of outdoor life, and knowledgeable friend of the Indian. As such, Akin is probably more familiar to the 1970's than he was to his own contemporaries. He came to Arizona in 1903 emotionally depressed, despairing of city life in New York, and resolved to find himself by living among the Hopi Indians.

For nearly a year he lived at old Oraibi (probably the first white man who had lived there for any length of time since the Pueblo Revolt of 1680) learning the language, adopting Hopi dress and participating in daily work and religious ceremonials. From the Oraibi experience Akin found himself as a person, got started as a painter, and began a lifelong association with the Hopis as friend and advocate. After leaving Oraibi he established a residence at Flagstaff, a small frontier town close to both the Hopi Mesas and the Grand Canyon.

The carefully posed formal Grand Canyon portrait, on the other hand, suggests how Akin wanted to be known and remembered — as the foremost painter of the Grand Canyon. If he did not entirely succeed in attaining that objective, it was not for lack of effort. Year after year he returned to the Grand Canyon until it became part and fiber of his existence: an adventure to explore, to live with, to comprehend physically and emotionally before applying paint to canvas.

Akin's accomplishments as a painter, especially as a landscape painter, were

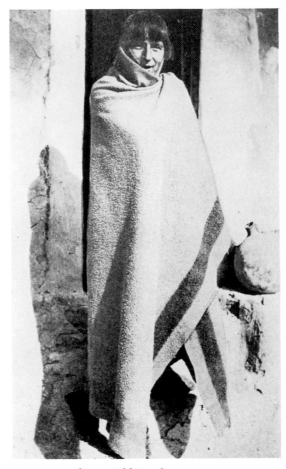

Akin at Old Oraibi — 1904

nationally recognized during his lifetime. But he never had a wide audience, partly because fashionable collectors of that period concentrated on European art while ignoring American painters. And his untimely death at age forty-four cut his career short just as it was gathering momentum. In the half century since his death his paintings have been almost forgotten.

Akin's acquaintances knew him as a moody, solitary individual with strong loyalties and a quick sense of humor. But he did not have many close friends, and today there are few people in Flagstaff who can recall any of the events and anecdotes that usually survive to be retold for generations in a small town. Always in debt, a little unkempt, probably regarded as somewhat eccentric and Bohemian, he stirred little interest at home even as his paintings acquired national fame.

The paintings speak for themselves; he was a realistic painter who needs little interpretation. His paintings of the Hopis reflect his intimate knowledge of that tribe and are significant ethnological documents. But his true talents are manifest in his direct and eloquent renditions of the strongly etched, chromatic landscapes of the Colorado Plateau country. In fact the very directness of rendition make his landscapes, at first glance, seem all too easy; it takes a few moments for the immense subtlety in color and perspective to register. Kenneth Clark once described another painter in words meant for Akin: "He was born with the landscape painter's greatest gift: an emotional response to light."

As with Thomas Moran, the Grand Canyon country was his favorite subject, and comparison of the two artists is both inevitable and instructive. Moran painted a dy-

namic, extravagant landscape charged with color and moving forces. Akin's best landscapes by comparison are painted in a lower and more literal key that suggests by understatement, heightening the subtle interplay between light, shadow and landform.

Akin was by no means the first good artist to paint in Arizona, but he was probably the first artist of national importance to make Arizona his permanent home and focus his talents on the Arizona landscape and its Indian inhabitants. As such, his work, together with that of contemporaries such as Moran, Dixon and Rollins, constitutes the beginning of regional art in Arizona, a much neglected subject.

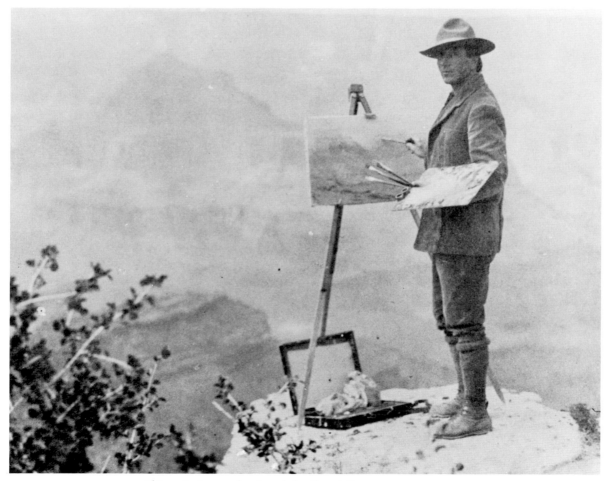

Akin painting at the rim of the Grand Canyon ca. *1905–1906*

Not much record remains of the artist's personal life. Today, sixty years after his death, there remains only a handful of oldtimers with a few dim personal recollections. He had no descendants. Fortunately, however, Akin wrote almost as well as he painted, and he left several essays of his experiences at Oraibi and elsewhere. They reveal something of his personality as well as providing valuable insight into life at Oraibi at the turn of the century. Some of the remaining gaps are filled by his surviving letters to friends and patrons, which provide a frequently entertaining and occasionally depressing picture of the difficulties of earning a living as an artist. The following pages are thus, to a large extent, Akin's own story told in his own words and through his paintings.

1: A Bahana in Oraibi

LOUIS AKIN DESCENDED from two generations of ill-fated Oregon pioneers. The Oregon experience commenced in 1852 when his grandparents, with their seven children, left Iowa by oxcart for Oregon. The mother and a young daughter died of illness along the trail; the father died just eight days after reaching Oregon. The eldest son, James, raised the family, eventually married, lost his wife and married again. From the second union, Louis Akin was born near Corvallis, Oregon, on June 6, 1868. Yet another generation of orphans resulted from the death of both parents before his thirteenth birthday. Thereafter he was taken into his uncle's household, where he apparently had a normal childhood attending school and working in the family shoe store after school.

From earliest childhood he was outdoors at every opportunity. A childhood friend recalled his first encounter with Louis Akin, then thirteen:

> . . . in the side yard of a tiny home at East Portland, Oregon, a small boy laid out upon the grass a row of brook trout which he had inveigled from the waters of Tyan's Brook during the long hours since daylight. Nellie Matlock, the little girl next door, stood on tip toes, with her chin between the pickets of the fence, to admire the catch, and said: "Do you know Louis Akin? He is lots of fun and he just loves to go trout fishing."
>
> I promptly hunted up Louis Akin, and three days later we played hooky for the first time to go trout fishing. We had played hooky off and on nearly ever since.

As he grew older he developed a solitary love of wilderness, spending days at a time alone in the Cascades, camping, trapping birds, studying the habits of mountain

1

sheep, and climbing mountains. In 1894, he was among a hardy group that climbed Mt. Hood in a sleet storm to form Oregon's first mountaineering club — The Mazamas — at the summit. The name (Spanish for "mountain goats") was Akin's contribution.

His talent for painting was evident at an early age. A cousin who had taken art lessons in California gave encouragement. On one occasion she encountered him painting a cat and kittens nested in an apple box. Unable to render the box firmly on the floor, the young painter turned to her for a first lesson in perspective. But formal training was apparently not available and his skills were largely self acquired. A career as a landscape painter would have been a natural blend of his painting talent and love of the outdoors, but there was little opportunity for local artists, and the best the young artist could do was to apprentice as a sign painter. He worked on and off at sign painting until he was twenty-eight years old. By then he recognized the need for formal training and a wider audience if he were ever to make a living as a serious artist. Reluctantly, he left Portland and moved east to New York City.

Akin arrived in New York with little money and just one or two contacts. Eventually he enrolled in the famous New York Art School directed by William Merritt Chase. He studied for perhaps six or eight months before dropping out, probably because he had neither the money nor the temperament for prolonged academic instruction. Nonetheless he stayed on in New York, taking odd jobs as a commercial artist and illustrator of outdoor life magazines while continuing to develop his painting skills. His elaborately filigreed calling card from that period gives his full name, Louis Benson Akin, lists his address as 162 East 23rd and modestly refers to his occupation as designer specializing in "line, wash or water color drawings for all purposes."

None of his paintings from these early years are known. But a letter written in 1901 indicates that he was unhappy with city life and increasingly moody and depressed. A poem, entitled "Tantalus in Town," written and illustrated for *Harper's Weekly* that same year is pervaded with a personal flavor that suggests his desire to leave New York and get back to the outdoor life he had known in Oregon. He began casting about for any opportunity that would give him a chance to paint in the West.

The opportunity appeared in the summer of 1903 in the form of an offer from the Santa Fe Railroad. Santa Fe would provide transportation to Arizona in exchange for a commitment to paint the Hopi Indians for a Santa Fe advertising campaign. Akin eagerly accepted. In popular imagination, the Hopis were the very last of the noble sav-

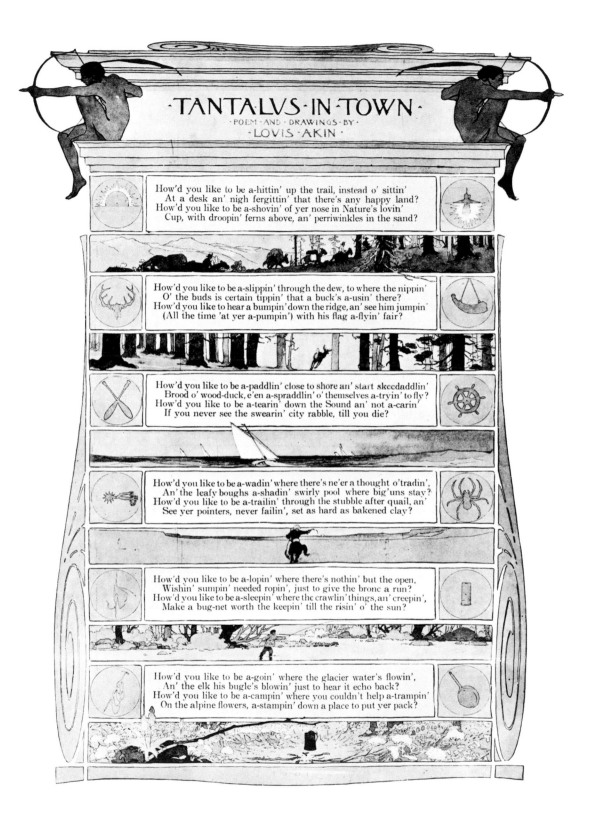

· TANTALUS · IN · TOWN ·

· POEM · AND · DRAWINGS · BY ·
· LOUIS · AKIN ·

How'd you like to be a-hittin' up the trail, instead o' sittin'
 At a desk an' nigh fergittin' that there's any happy land?
How'd you like to be a-shovin' of yer nose in Nature's lovin'
 Cup, with droopin' ferns above, an' perriwinkles in the sand?

How'd you like to be a-slippin' through the dew, to where the nippin'
 O' the buds is certain tippin' that a buck's a-usin' there?
How'd you like to hear a bumpin' down the ridge, an' see him jumpin'
 (All the time 'at yer a-pumpin') with his flag a-flyin' fair?

How'd you like to be a-paddlin' close to shore an' start skeedaddlin'
 Brood o' wood-duck, e'en a-spraddlin' o' themselves a-tryin' to fly?
How'd you like to be a-tearin' down the Sound an' not a-carin'
 If you never see the swearin' city rabble, till you die?

How'd you like to be a-wadin' where there's ne'er a thought o' tradin',
 An' the leafy boughs a-shadin' swirly pool where big'uns stay?
How'd you like to be a-trailin' through the stubble after quail, an'
 See yer pointers, never failin', set as hard as bakened clay?

How'd you like to be a-lopin' where there's nothin' but the open,
 Wishin' sumpin' needed ropin', just to give the bronc a run?
How'd you like to be a-sleepin' where the crawlin' things, an' creepin',
 Make a bug-net worth the keepin' till the risin' o' the sun?

How'd you like to be a-goin' where the glacier water's flowin',
 An' the elk his bugle's blowin' just to hear it echo back?
How'd you like to be a-campin' where you couldn't help a-trampin'
 On the alpine flowers, a-stampin' down a place to put yer pack?

ages, an Indian tribe untainted by civilization, still practicing ancient snake rituals on their remote mesas, doomed to eventual extinction. They were ideal material for a painter eager to make a reputation. Moreover, no painter had ever worked among them for more than a few days. He promptly dropped his work, gathered together a few belongings and commenced the long journey by train to Arizona.

He arrived in northern Arizona in September of 1903. Maynard Dixon, who traveled through northern Arizona in that same year, described the kind of reception that Akin probably received:

> In those days in Arizona being an artist was something you just had to endure — or be smart enough to explain why. It was incomprehensible that you were just out "seeing the country." If you were not working for the railroad, considering real estate or scouting for a mining company what the hell were you? Drawings I made were no excuse; and I was regarded as a wandering lunatic.

Akin promptly set out by horseback for Oraibi, a two-day ride north from the railroad, up the sandy washes and clay cliffs of the Painted Desert to Third Mesa. He wrote of his first approach to Oraibi:

> . . . The first faint view of Oraibi, the largest village, is gained five or six miles down the trail, where by close attention the block-like houses can be picked out and distinguished above the like-formed rock of the mesa which they crown.
>
> In following the horse trail directly, the view grows plainer and then is lost, as the way winds closer, up through scrubby peach orchards and melon patches, past a deep, Oriental-looking spring, then squarely up a narrow, precipitous passage where your pony climbs like the goat he has to be, and out on the summit full into the village street. At once everybody in town knows there are strangers within the walls. It isn't wireless — it's dogs.

Akin's immediate objective was making the necessary arrangements for a place to stay and he later recounted his search:

My first visit was on a flat hunting expedition, accompanied by youthful Mah-sí-wa, who could speak a little English, and the first place I entered was the one I wanted and finally secured. It was the upper floor of a two-story house, occupied then by the family, but Nav-ah-hong-a-ni-ma was willing to rent it out and move downstairs, as it was nearing autumn when they all move into the lower stories for more warmth. So, upon my quickly agreeing to pay her seventy-five cents a week for two or three weeks — all she asked and which astonished her, for she had expected me to offer her twenty-five cents, and have an hour's joyous haggling before coming to an agreement at fifty — she moved her few chattels out and swept the floor.

He described his new Hopi home with the eye of an artist imagining the possibilities for a painting:

In three corners were tiny, quaint fireplaces, one a sunken oven, and in the other corner the mealing stones, set in a shallow trough in the adobe floor with a wee, unglazed window beside them. A broad, low banquette on one side offered a cozy couching place with another half partition at one end, giving it semi-privacy. Then there were sundry cubby holes in the walls and a couple of storage bins which furnished seating space. The stone walls were smoothly plastered with adobe by hand, in a way that leaves no square corners or hard, straight lines, and all but the floor was neatly whitewashed with pure, white clay.

Hung to pegs near the ceiling, and forming almost a frieze around the room, were bunches of dried herbs, red peppers, dried muskmelon, dried boiled sweet-corn-on-the-cob, neat packages of corn-husks cured for various uses, and ears of choicest corn of many colors for next year's seeding. All this I asked her to leave, for I liked it, and also I kindly permitted her to leave a large pile of cool, ripe watermelons in one corner. Then she brought water in a wikurra, I bought a load of scrubby fagots that Sah-koy-um-na had just brought in, unpacked my few food supplies from the traders, and my blankets and painting duffle, and was at home. "At home" is correct. That first day was my reception day though no cards were sent out. Nearly all the men in the village, some of

HOPI WEAVER 1904 oil, 14 x 20

Collection of Julie Ganz

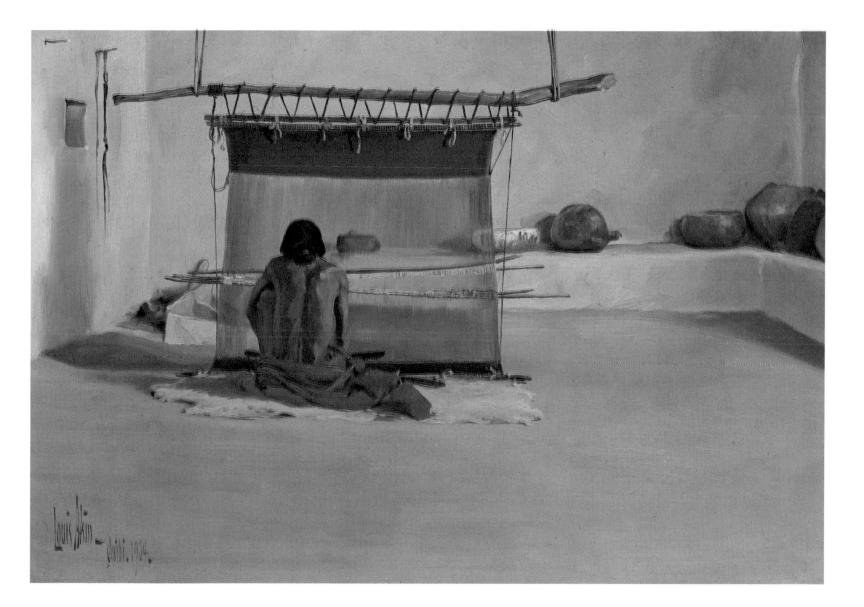

the women and a few of the bolder or more curious children came. All were interested to know what object I could have in coming there and settling in such an apparently permanent way in the midst of them.

The intense curiosity at this stranger come to live among them was not difficult to fathom. Completion of the Santa Fe Railroad tracks across northern Arizona twenty years earlier had brought the Hopi into abrupt and painful collision with the white man's world. Indian agents and school teachers came to regulate and regiment their lives, traders entered with new goods, missionaries with new religions. The old and the new did not blend, and confrontations developed over virtually every facet of Hopi life. The most inflammatory issue was education. Indian agents insisted that children be placed in the schools; conservative Hopis were adamant in their refusal to comply. More than once the agents resolved a dispute by calling in troops to intimidate parents and to extract terrified children from their hiding places and carry them off to the schools. During the summer before Akin's arrival, mistreatment of the Hopis had become a national issue as Charles Lummis and the Sequoya League pressed sensational charges that Indian agents were shearing the hair of Hopi children and forcing them to school at gunpoint.

By the time Akin arrived in Oraibi, these conflicts, intensified by long-standing clan rivalries, had divided the village into bitter factions living in a precarious coexistence. Considering the tensions caused by the coming of the white men, it seems remarkable that Akin was allowed to remain. Whatever skills of persuasion he used to obtain permission to live in their midst, the Hopis apparently did not regret their decision. Akin wrote:

These gentle folk are very susceptible to gentle treatment and it wasn't long till I began to feel highly gratified to see that I was winning their confidence to an unexpected degree, even in the conservative faction. Yes, even the children, playing about the streets in their little bronze pelts, soon reached a point of confidence where they wouldn't run screaming for home or the nearest shelter when I appeared, and eventually the time came when they'd run joyously to me, calling me by name — my Hopi name — instead of scattering; then, indeed, was my pride unspeakable. The ambitions of a few recent school teachers to augment their roster had led them to drag their nets very closely for

8

kindergartners, and the unnecessarily brutal means they employed were quite truly enough to justify all mothers and weaned infants in their terror of a Bahana.

Quietly going about his work, demanding nothing and eager to learn, Akin gradually became absorbed into the communal life in Oraibi. He began learning the Hopi language. A picture taken that year shows him standing outside the doorway of his dwelling wrapped in a Hopi robe, wearing moccasins and the traditional long, square-cut bangs of the Hopi male. He stayed through the winter and lingered on into the next summer, eagerly soaking up the details of the intricate ceremonials as they progressed through the seasonal cycle. Before a year had passed he was adopted into one of the clans. A friend later wrote: "After he had lived with the Hopi a year or so, he was initiated into one of the secret societies of the young Hopi men, danced with them in their underground lodgeroom, the Kiva, and ran with them on their visits to their neighboring villages.

Today there are one or two old Hopis still living in the ruins of Oraibi who recall Akin's stay among them seventy years ago. One of them, Don Talayesva, remembers Akin as a big, husky man who lived and dressed like a Hopi. Don and the other children called him "Mapli" (meaning "without sleeves") because of the sleeveless shirts he wore during his first weeks in Oraibi.

Not everyone, however, was pleased at Akin's friendship with the Hopis and admiration for their lifestyle. The Indian Commissioner's Annual Report for 1904 included some irate comments from the Field Matron who probably had Akin in mind when she wrote: "I wish the Department could realize the influence of some of the tourists who come here. Their own costumes have a very demoralizing effect and they encourage the Hopi in wearing their hair long and clinging to Hopi clothing, customs, and superstitions."

Akin's own account of his experiences at Oraibi is a lyrical, perhaps somewhat idealized, exposition of the qualities of life in a Hopi village. Hopi life, he wrote, is "a religion of environment," and he continued:

I didn't do much actual work, the conditions were against it. There was too much of living interest in this new world that I found myself a part of. How

9

could I paint when Ke-wan-i-úm-ti-wa came to spend an afternoon in my education, making me get up and "act out" things to be sure I had my lessons right? How could I paint when an old grandmother wanted me to see by every detail how much better than modern methods was the good old way of building up the clay for a piece of pottery? Or, when Pu-hú-nim-ka, with a tiny yucca-fiber brush in her deft, tapering fingers, permitted me to watch her penciling the old, intricate design on one of her gracefully modeled bowls? Or, when Ku-ku-tí-ti-wa, the lame boy, came to borrow tools and get advice in fashioning a finger-ring of lead, set with a rough, blue stone, the model for one he planned to make in silver and turquoise when he had acquired the necessary tools and knowledge for that advanced work? How could I paint when there was a rabbit drive to join, or the spinning "bee" for the bridal robes of some good friend's daughter, or a ceremonial foot-race, or when our Katcinas were going to Shungopavi to dance, to show "those Shungopavis" how easy it is to make the rain come when a people have superior knowledge and stand high with the Cloud Spirits, or when there was a nine days' ceremony on at home and never a minute of it, day or night, that hadn't some real interest in it.

So I didn't paint and there are no regrets. When old Ho-vé-i-ma, the crier — he of the great voice — stood on the highest house-top and announced that on the third day all were invited to come to the fields of one who was too old and feeble to get his planting done alone, and help him to finish it, it was worth more to me to join the groups that trailed down into the plains before sunrise and see two weeks' work done in a few hours by people who live very near to the Golden Rule. And the charm of it is that such communal work is done with the utmost cheerfulness; song and laughter are everywhere, and when the task is done there's always a big dinner ready at the home of the one benefited, in which also the woman of the house had had the co-operation of her friends. Such occasions come often, as when a man wishes to start a new blanket. If he were to spin all the yarn alone he'd spend weeks at it; but let him invite his friends to come to a kiva on a certain day to help him, and presto! all the yarn is spun in no time, everybody has a good, social time and a dinner, and he is ready to set up his loom next day.

Despite his preoccupation with living Hopi life instead of painting it, Akin did find some time to produce paintings. During his year-long stay, he completed perhaps 25 to 30 canvases. These Oraibi paintings, dated 1903 and 1904, are his earliest known works. But it is evident from them that he was already a mature artist, possessed of the highly-developed sense of color and perspective that distinguishes his work.

The best painting from that year, *In Oraibi Plaza*, became one of the most familiar of Southwest Indian paintings. In 1905 it was exhibited and featured as a catalogue illustration in the Annual Exhibition of the National Academy of Design. In 1906 the painting was reproduced and given wide distribution. The original was subsequently destroyed in a fire, but even in reproduction the merit of *In Oraibi Plaza* is manifest. Three Hopi men wrapped in loose, full-length robes of desert pink, their faces partially obscured by the traditional long hair, move silently through the plaza into the foreground. Behind them the cluttered roofs and terraces of the pueblo are coming alive with smoking chimneys, women at work, and children ducking into passageways. In the distance the cliffs of Second Mesa reflect through miles of transparent morning air. Overall, the painting perfectly captures the fresh, living quality of a desert morning on the Hopi mesas.

Other Oraibi paintings depict individuals engrossed in the routine tasks of daily living: an old man spinning wool, another at his loom, studies of women grinding corn upon the metate, a basket weaver, a woman sorting corn against an autumn background of chile peppers drying in the sun. There is one other exceptional painting from this period. One day Akin ventured out into the desert below Third Mesa and happened upon a group of Navajos engaged in the traditional sport of *Na'ahoohai* — the chicken pull. The target was a chicken buried alive to its neck in the desert sands. Mounted on horseback, the contestants circled the chicken at top speed, each attempting to win by pulling up the chicken. Akin's painting of that scene focuses upon the spectators in the foreground, two colorfully-dressed squaws on horseback and a boy languidly stretched across his horse dreaming of the day when he will join the riders rushing by in the background. The picture, purchased by the Santa Fe Railroad, provoked much comment, and one Chicago art dealer well attuned to the market for Indians on horseback suggested that Akin paint more subjects like it. But his interests were with the Hopis, and it is apparently the only study he ever did of the Navajos.

NAVAJOS WATCHING FIELD SPORTS 1904 oil, 14 x 30

Collection of Mr. and Mrs. Paul J. Babbitt

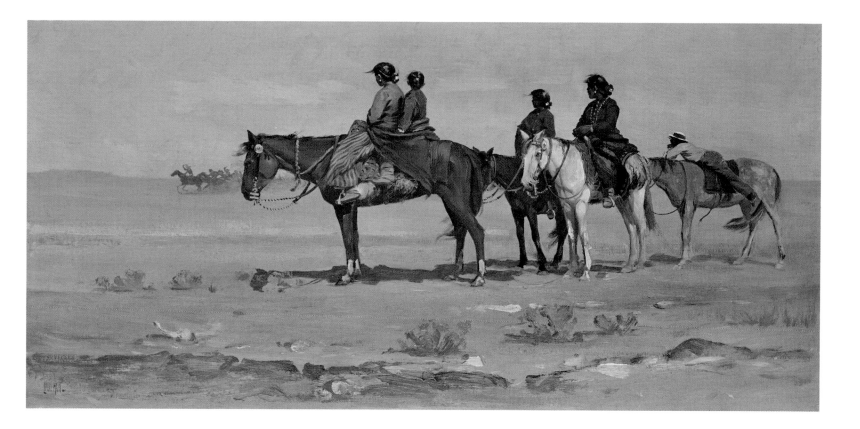

2: An Artist in New York

AKIN FINALLY DEPARTED from Oraibi in September of 1904 shortly after the snake dances were over. From Oraibi he moved to the Grand Canyon to paint for several months before returning to New York City in January of 1905. There he opened a studio on the top floor of a brownstone house at 45 East 20th Street, across the street from Theodore Roosevelt's birthplace. He set to work completing his paintings and renewing old friendships, but the Hopis were never far from mind. In February he wrote a letter to Francis Leupp, the newly appointed Indian Commissioner, offering his views on a dispute involving the trader at Oraibi and concluding: "I am very deeply interested in the welfare of the Hopis, and hope to have an opportunity of talking with you about them before I go down there again this summer. They are a people who are deserving of much discrimination and care in their education, for they are possessed of the necessary innate qualities of intellect and industry to make them a model community if properly nurtured."

For a while he even considered the possibility of establishing an artists' colony on one of the Hopi mesas. Since organization was not his forte, the colony never got underway, but he did recruit one artist: Kate Cory who was to become a well-known painter of the Hopis. She later recalled how she was recruited during that winter in New York:

> It was back in New York on an afternoon at a social gathering of the Pen and Brush Club of which I was a member. I was chatting with my good friend, the writer Maude Banks, the daughter of General Banks of Civil War fame. Suddenly Maude looked to one side and exclaimed, "Why Louis Akin, where have you been all this time?" She introduced me and we sat down on a nearby couch as Akin answering the query said, "I've had a wonderful winter out in

14

Arizona in the Hopi reservation." He then told us of the mild winter in Arizona, of the little rock and adobe houses and ancient villages of those gentle people with their strange ceremonies and customs. Then he added, "I want to go back there and have a colony of writers, artists and musicians. Why can't you two be of that colony?" It sounded attractive and since my parents had both passed away there was no reason why I could not go. . . . I entrained for Arizona and the Hopi Reservation. I had written ahead to the trader at Canyon Diablo at the suggestion of Louis Akin, and had sent to him a box of necessities. It materialized that Louis' plan did not bring the party to the reservation and thus I became the "colony."

Akin's main objective in returning to New York was to exhibit his work, and he soon obtained a commitment from the Clausen Gallery on Fifth Avenue. It was his first one-man show and he prepared it carefully. The Hopis, then as now, had great romantic appeal, and he carefully arranged the exhibit in a setting of Kachina masks and bows and arrows from Oraibi. On the last day of the exhibition he gave a lecture on his experiences at Oraibi. The show was well attended by the newspaper critics, who were intrigued by the subject matter but lukewarm about his merits as an Indian painter. One critic wrote:

> Mr. Akin is a young man, and he has technical limitations which keep him, in his treatment of the figure, from rising above an ordinary level. The most that can be said for such of his Indian subjects as *Peppers*, *The Plaza* and *Woman's Work*, is that they give a mildly clever account of facts in themselves picturesque. We take these studies more as promising good work in the future, in a field worth exploration, than as intrinsically good examples of the painter's art.

But the critics did not entirely demolish his standing as an Indian painter. The superb *In Oraibi Plaza* was exhibited by the National Academy, and a feature article on his Indian paintings appeared in 1906 in *Brush and Pencil*, a national art magazine. The author of that article perceptively pointed out the importance of the Hopi paintings as documentary art, stating: "They are noteworthy . . . as a witness of the efforts of a

promising painter — one among many — to record the life and habits of a vanishing race. They are human documents — less artistic, it may be, than some of the work of Sharp and Couse, but quite as important and fully as replete with interest as that of Burbank, Phillips, and others who have made the Indians a specialty."

The *Brush and Pencil* article was prophetic in at least one sense. Although the Hopis have not vanished, Oraibi itself has all but disappeared. Torn by internal dissension in 1906, the village was gradually abandoned and has disintegrated into a pile of ruins that only faintly suggests the great labyrinth of buildings and plazas that had flourished for almost a thousand years.

The Grand Canyon paintings shown at the Clausen exhibit provoked a different reaction. The very critics who were so lukewarm about the Hopi paintings had lavish praise for his landscapes. The reviewer for *The New York Times* wrote:

> As a landscapist and painter of atmosphere Mr. Akin is indeed successful. The ten views from the Grand Canyon are not all equally attractive, but all have interest and some are strangely beautiful. Instead of painting in the pitilessly clear and crystalline air that usually exists in that dry land, he has chosen days when fine mists soften the sharp edges of things and bring the startling colors of the earth and crumbly rock of that land of rainbow-colored cliffs into a soft harmony. By a singularly masterful management of values, he indicates the enormous void that lies between this wall of the canyon and yonder cliff in the background . . .
>
> The little exhibition is one that no one should miss.

All but two of the ten landscapes that drew this praise have dropped from sight, but those two amply demonstrate why the critics were so impressed. The first, entitled *Manu Temple*, was painted in 1904 and is thus his earliest known painting of the Grand Canyon. The viewer looks out across Manu Temple to the North Rim from the head of Bright Angel Trail. Across the river, the middle distance recedes into the remote horizon through planes of subtly differentiated Paleozoic temples and buttes, all emanating a rose-colored hue that seems to come from within the earth itself.

The second painting, entitled *A Summer Storm*, carries the superb atmospheric effects of *Manu Temple* into a late afternoon thundershower over Bright Angel Creek.

The background, darkened by the storm, comes through in tones of deep, luminous blue, while in the foreground sunlight breaks through the clouds to envelop a projecting butte in brilliant pink sunlight. The painting was reproduced for sale at the Harvey Houses along the Santa Fe line; the original was later destroyed in the same fire that consumed *In Oraibi Plaza*.

The other newspaper reviewers at the Clausen exhibit were unanimous in their praise of his landscapes. The same reviewer who thought his Hopi studies "ordinary" and "mildly clever" continued:

> But in his landscapes Mr. Akin has already something to say, and says it with a skill and individuality. We call his pictures of scenes in the Grand Canyon "landscapes," but it would be perhaps more accurate to call them visions . . . Painting them with a keen eye for substance, but more especially with a feeling for the subtle atmospheric phenomena enveloping his scenes, Mr. Akin has set upon the canvas chromatic harmonies which recall the improvisations of Turner rather than dispassionate observations of the modern school.

A third critic was just as enthusiastic:

> The ten Grand Canyon pictures are wondrous visions of color and forms, great masses of rock rising high up against the skyline. Mr. Akin not only elected to paint these serried piles of the basaltic rocks at the sunset hour, when their natural grandeur was glorified, but he also presents them as seen in the light of misty days, when they seem visions of another world rather than of this.

There were not many sales, but the favorable critical reaction was all important and Akin was elated at his success. A few days after the exhibit closed he wrote to an old friend regretfully stating that he could not scrape together enough money to attend the friend's wedding in Oregon. On a more cheerful note, he recounted his artistic success:

> My Grand Canyon pictures were received by the press, critics and the public

IN ORAIBI PLAZA 1904 20 x 14

Lithographic Print by Detroit Publishing Company

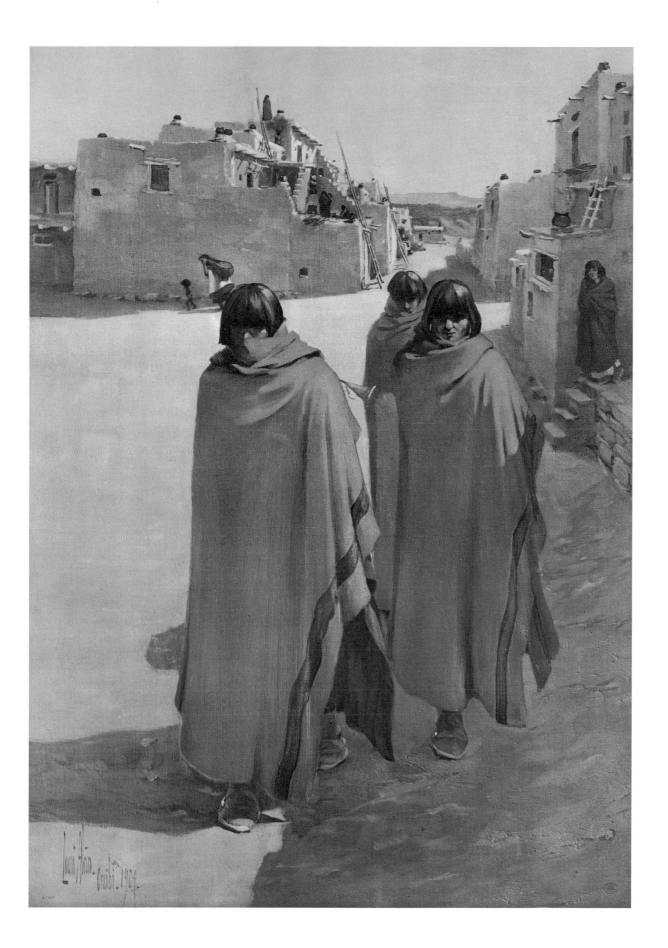

with a spontaneous approval and praise — putting me away up in the front row of American painters — in company that scares me stiff — but I'll try to stay with them. It's a damnable piece of irony though to be threatened with dispossession and starvation at the same moment.

ANCHA-A!

3: The Grand Canyon — Fame and a White Elephant

SOMETIME AFTER THE Clausen Gallery exhibit Akin decided to make Arizona his home. He wanted to return to the Southwest, and he was now reasonably sure that his Arizona work would provide him the national recognition he desired. Personal factors also played a part in his move. A romance that had lingered on from his early days in New York City was terminated in 1905 when the girl announced her engagement to another suitor. (Akin thought his rival "as foul a blackguard as ever disgraced a decent family.") Moreover, doctors advised the Southwest as a remedy for recurring lung problems, probably involving tuberculosis. So when he returned to Flagstaff in the spring of 1906 he rented a studio apartment with the intention of making it his home.

He brought with him to Arizona a commission from the Santa Fe railroad to make a painting of El Tovar, the luxury hotel that Santa Fe had just built on the South Rim of the Grand Canyon at a cost of $250,000. Santa Fe's promotional literature for El Tovar proudly proclaimed, "The architect has combined in admirable proportions the Swiss chalet and the Norway villa." With Akin's help El Tovar was destined to become a Santa Fe trademark.

Akin completed the painting in 1906, and it must have met Santa Fe's highest expectations. El Tovar fills the left background, its warm, rustic façade partly obscured by piñon pine. A Hopi woman with child bundled on her back and a Mexican rider on horseback travel a path leading from the hotel through the piñons into the foreground. To the right, the brink of the Canyon drops off and opens out in an array of mid-morning pastels. Across the Canyon, cumulus clouds build toward a mid-afternoon shower. Combining a powerful view of the Canyon with an unobtrusive impression of El Tovar, the picture is considerably more than just commercial art.

The painting was widely distributed in reproduction and quickly became one of

the best-known paintings of the Southwest. Reproductions framed in dark oak and set with a small brass plate captioned "El Tovar" were distributed for hanging in stations and ticket offices throughout the nation. A smaller thistleboard reproduction was sold at Fred Harvey Curio Shops along the Santa Fe, and full-size paper lithographs were also distributed. In a short time the painting was nearly as familiar a trademark as the Union Pacific buffalo. The framed reproductions still hang in a few out-of-the-way Santa Fe train stations, and they still turn up in second-hand stores for five or ten dollars. More frequently they are found in the hands of Western Americana dealers who ask prices of from $50 to $100. The painting appeared in yet another form in 1906 when Santa Fe used it as the cover illustration for a well-known book of Grand Canyon essays by such notables as Thomas Moran, John Wesley Powell and Charles Lummis.

Other well-known purchasers helped to build a market for Akin's Canyon landscapes. One was William Allen White, the colorful Kansas newspaper editor, who visited the Grand Canyon in 1906 and even rode a mule down to the Colorado River. He later wrote of his adventures there, concluding, "The Canyon is too fresh from God's hand for man's mind to conceive in terms of art." Nevertheless, sometime during or after that trip he discovered Akin's Canyon paintings, described them as one of the great things in American art, and purchased one for his home in Emporia, Kansas.

Emery Kolb, the famous river man, recalls that he received a Grand Canyon painting from the artist in 1906 in exchange for photographing some of Akin's work. Kolb, now 92, still owns both the painting and several of the glass negatives he prepared for Akin.

Despite his growing reputation, Akin remained continually in debt. He still owed $225 to William Volz, the trader at Oraibi, apparently for supplies purchased during his first stay with the Hopis. Martin Buggeln, a hotel proprietor at Grand Canyon, dunned the artist for payment of an old $282 bill, referring to him as a "hotel beat."

He frequently turned to friends for loans to tide him over until another purchaser came along. In a letter to Bill Crane, a boyhood friend, thanking him for a recently received loan, he wrote: "I was right up against the primary question of food and house-room — absolutely at the end, far as I could see. So I utilized it with utmost gratitude towards a new lease on life — and had three meals today for the first time for awhile." And in a letter to W. H. Simpson, Santa Fe's advertising manager, thanking him for having purchased a painting, he wrote good-naturedly of his financial plight:

The draft arrived yesterday — thank you — and like the rose — or the snows — it is gone today — to where it will do the most good. I even had to turn down an old Hopi friend who buttonholed me a while ago and in true civilized form tried to touch me for a dollar. I explained to him that while he had no money but plenty piki — I hadn't either — and advised him to part with the four two-bit buttons adorning his front elevation.

Part of the problem, in Akin's mind, was the limited market for Grand Canyon pictures. He explained to Simpson, "There are many things I can paint that sell better than Canyon pictures — probably nothing I could paint that would sell so slowly. But I've painted it because I am fascinated with it and because it has been an achievement worth many vicissitudes."*

He finally decided that a dramatic artistic venture was the only way to capture public imagination and free himself from constant financial worries. As a solution, he conceived of painting a sunset panorama of the Grand Canyon on a mammoth canvas that would match the scale of the Canyon itself.

The gigantic landscape was nothing new in American painting. Bierstadt had painted huge vistas of the West in which the observer could count hundreds of individual buffalo and Thomas Moran had painted a 4 by 12 foot panorama of the Grand Canyon that Congress had purchased for $10,000. Akin probably had these popular precedents well in mind when he started to work.

He selected a view from below Yuma Point on the old Boucher Trail. The spectacular views from this trail made it a favorite of many Canyon painters; Akin considered it the most comprehensive view from any point in the Canyon. He began by painting a 16 by 24 inch study of the scene entitled *Sunset Glow* and then moved to his Flagstaff studio apartment where he set up a 6 by 9 foot canvas. He became totally engrossed in the painting during the spring and summer of 1907, often awakening in the middle of the night to work on the canvas and frequently feeling despondent about his ability to handle a work of such size. Henry Albers, a young sheepman living in the same building, recalled that the artist took him aside one day and asked, "Tell me — as an ordinary

*Akin's love of the Grand Canyon as subject matter is attested by the high percentage of his total work devoted to that subject. Of approximately 125 Akin paintings identified by the author, about 35 are of the Canyon.

SUNSET GLOW 1907 oil, 16 x 24
Collection of Mr. and Mrs. Bruce E. Babbitt

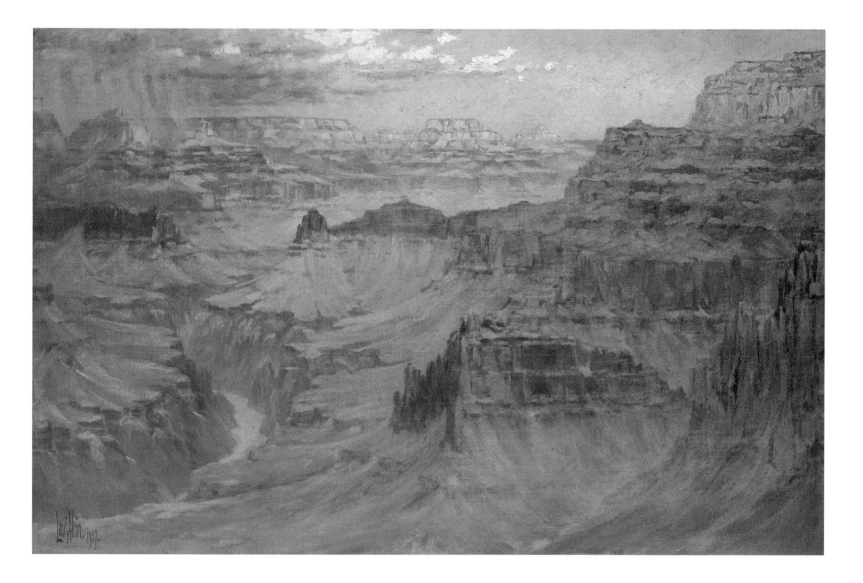

man — do you like it? Tell me the truth." Akin had him stand in a corner to view the picture from an angle but then as if to avoid getting an answer said, "Tell me tomorrow."

The painting was completed in the summer of 1907, although Akin never signed the canvas. A few months later, he described the painting in a letter:

> It is from the upper terrace of the red sandstone — evening — the depths in diffused hazy shadow and the distant high points glowing in the last rays of the sun — an evening storm drifting up the north rim and pouring rain into the deeply shadowed amphitheatres beyond Brahma and Zoroaster. The river is nearly under us there and is dull and brown and hazy in the dark depths of the gorge in the lower left of the picture.

He first exhibited the painting, entitled *Evening — Grand Canyon*, to Flagstaff townspeople on Saturday, August 10th, and it was predictably well received by a large turnout of ladies and their somewhat reluctant menfolk. The *Coconino Sun* reported, "Saturday, Mr. Akin at his studio in Babbitt Block, exhibited to a large number of visitors his latest painting of the Grand Canyon. The painting is a large one and is considered by those who know, to be the best painting yet by Mr. Akin of that scenic wonder."

The crucial test of his efforts, however, would come not in Flagstaff but in the eastern art exhibitions. Simpson, his friend at Santa Fe, came to his assistance by agreeing to ship the painting without charge to New York. Simpson also arranged for the painting to be shown by a Chicago art dealer in that city for a few days before forwarding it to New York. Akin still had mixed feelings about the painting, but knew that to be successful it would have to be promoted well. He wrote Simpson cautioning, "Now this big picture is either of very great importance — or none at all — there can be no half way business about it. Therefore it is entitled to either the most dignified presentation to the public — or — not at all."

From Chicago, Santa Fe sent the painting to New York for entry in the annual exhibition of the National Academy of Design. Akin cautioned against public disclosure of Santa Fe assistance writing, "if it were known at all that the Railroad Company were behind it, it would stand mighty little show for getting attention or a chance for exhibition . . ." Simpson responded by enclosing a copy of his shipment letter noting, "My letter to them is written on personal stationery, instead of the official letterhead of the Santa Fe,

so there is nothing in the correspondence to connect the railway with the transaction."

As the exhibition date approached, Akin wrote to Simpson in an optimistic frame of mind: "Now this is 'big game' and worth having a shot at. It would be taking a chance of course but if they should accept the big picture — its very size will command for it a very prominent position in the hanging. They have accepted pictures as large heretofore and no jury has yet rejected my work anywhere." But his optimism was misplaced. The National Academy jury rejected the painting on the ground that it was too large. He then attempted to enter it in the Pittsburgh Exhibition where it was again rejected because of its size. Disappointed but undaunted, Akin put the painting into storage, still confident that it would ultimately receive the recognition that he felt it deserved.

Two years passed by and the painting was not sold. Again hard pressed for money, Akin made a final intensive effort to dispose of the painting. In October of 1909 he wrote to Simpson from New York: "I believe the time has come for me to get rid of my pet white elephant — it is eating its head off in storage. Meaning my big Canyon picture. I had decided to cut it in two and use the canvas for two new pictures — but I want first to give you a chance to buy it at a bargain. Santa Fe may have it for a $1,000 in real money if they speak quick enough."

Simpson replied from Chicago that he expected to come to New York soon and would be willing to discuss the picture, but, he wrote, "cannot offer much encouragement now, as our art fund for this season is about used up. Cannot afford to put $1,000 into a picture merely to hang on the City Office's walls, and am not ready to pick out one to be reproduced. We need another lithograph of the Canyon alone, but I do not think the right one for that purpose has been painted. It must have not only art quality but advertising value."

Akin's response was prompt and insistent: "I firmly believe you are underestimating an opportunity! In the first place I wouldn't sell that picture to hang on 'City Office's walls' — it was never designed for such purpose. It should hang in some high-class hotel where it could have a good lighting and be seen by the right sort of people and plenty of them. There are surely a lot of such places available and where it would be welcome for its own interest. I offered it to you at $1,000 because I need the money *now* — that price won't hold good very long. The picture has been appraised by the best of authorities at $5,000 which is the price I have held it at — and it is a good enough 'work of art' to have been recommended for purchase by the curator of paintings of the Met

MORNING — HERMIT CANYON 1907 oil, 12 x 16

Collection of Museum of Northern Arizona

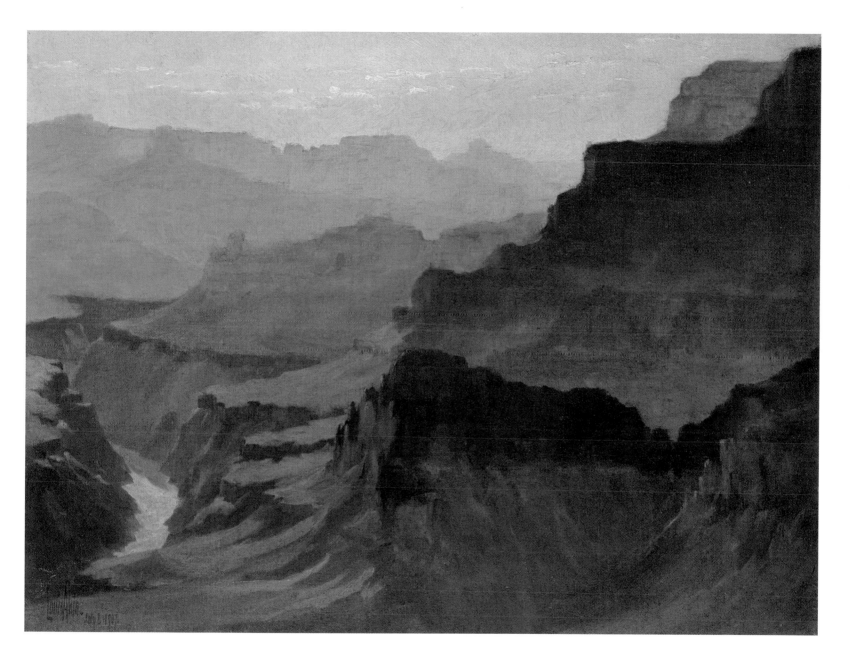

Museum. Unfortunately for me however Sir Pruden Clarke has persistently declined to buy any more American paintings until they have room to hang them."

A few weeks later Simpson arrived in New York, but he apparently remained non-committal. Refusing to give up, Akin seized the initiative by locating E. P. Ripley, president of the Santa Fe, who was also in New York, and imploring him to have a look at the picture. Ripley declined, stating that he trusted Simpson's judgment and would follow his recommendation. (Ripley had seen Akin's work previously and was not impressed; he preferred the Canyon paintings that the Railroad had purchased from Warren Rollins.) On the same day Akin went back to Simpson's hotel, tried unsuccessfully to contact him and left a note relating his conversation with Ripley and begging Simpson to discuss the matter with Ripley.

A week later, back in Chicago, Simpson wrote an office memo to President Ripley commenting:

> I have seen the painting. While an interesting work of art, it is rather large for City Office use, being 6 x 9 feet, and is hardly suitable for reproduction by color process, the tones being too somber. I do not recommend purchase of Akin painting for either of these two uses.

Ripley concurred and Simpson then wrote Akin finally terminating the discussions. "It has been decided not to buy your big Canyon picture. Such a fine canvas really ought to go in some big collection. Hope you will succeed in disposing of it soon to good advantage. Am awfully sorry that Santa Fe cannot buy it."

Akin obviously did not have the heart to cut up the painting for the canvas as he had threatened. But he never did find a buyer, for popular taste in art had changed and the big western landscape had become as antiquated as the buffalo and the stagecoach. He kept the painting for the rest of his life, and after his death his friend John Verkamp purchased it to hang in Verkamp's curio store at the Grand Canyon. The painting can still be seen at Verkamp's, and Akin would have been gratified to know that over the years it has begun to receive the recognition that he thought it merited.

Shortly after he finished painting the big Canyon picture, Akin became involved in a second grand project that held out prospects of national fame but finally yielded only disappointment. Robert Brewster Stanton, the leader of the ill-fated Colorado River expedition of 1889, had encountered Akin painting on the rim of the Canyon and liked his

work. Stanton was preparing a monumental history of the Colorado River that needed illustrations, and he invited Akin to collaborate with him on the project.

Stanton's immediate objective was to publish a magazine account of a controversial character named James White. White had emerged half starved and floating on a log raft from the lower end of the Canyon in 1867, claiming to have floated through the entire length of the Canyon. White was either a colossal liar or the greatest explorer of the time; the controversy continues to this day. Stanton had researched all the evidence, interviewed White at his home in Colorado, and decided that he was a liar who should be exposed as such.

Stanton explained to Akin how his pictures could help refute White's lies; White had told Stanton that the walls of the Canyon seen from along the River were composed entirely of white sandstone. Stanton explained that several colored views from along the River at the bottom of the Canyon should convince any reader that White was conjuring up fantasy.

Akin quickly warmed to the project and with the help of sketches and photographs already on hand he painted two representative views of the Inner Gorge seen from the River. The best painting, looking upriver from a spot near Bright Angel Creek, includes a broad sand bar spotted with yucca in the foreground. In the middle distance the river cuts through high walls of dark granite and in the background several high temples of red sandstone are dusted with winter snow. Akin wrote Stanton suggesting the title "A Christmas Morning" and explaining that the painting was inspired by a view from his camping site along the River on Christmas Day of 1906.

Stanton received the two paintings in New York City in February, 1908. He was surprised to find oil paintings since he had expected that Akin would simply color several photographs for use as illustrations. He wrote Akin, "The two paintings are the most beautiful I have ever seen of the canon, especially from the lower part looking up . . ." But in subsequent letters his engineer's mind took over, and he began to question whether the paintings were literal enough to provide a scientific refutation of White's testimony. But Stanton had an even bigger problem — he could not find a publisher for either the exposé of James White or his overall history of the Colorado. Eventually Akin requested the paintings back for an exhibition and the project never materialized. Stanton never did find a publisher; his failure to do so strangely echoes Akin's inability to find a purchaser for his big painting of the Canyon.

A CHRISTMAS MORNING 1908 oil, 30 x 20

Collection of Mr. Merrill Bittner

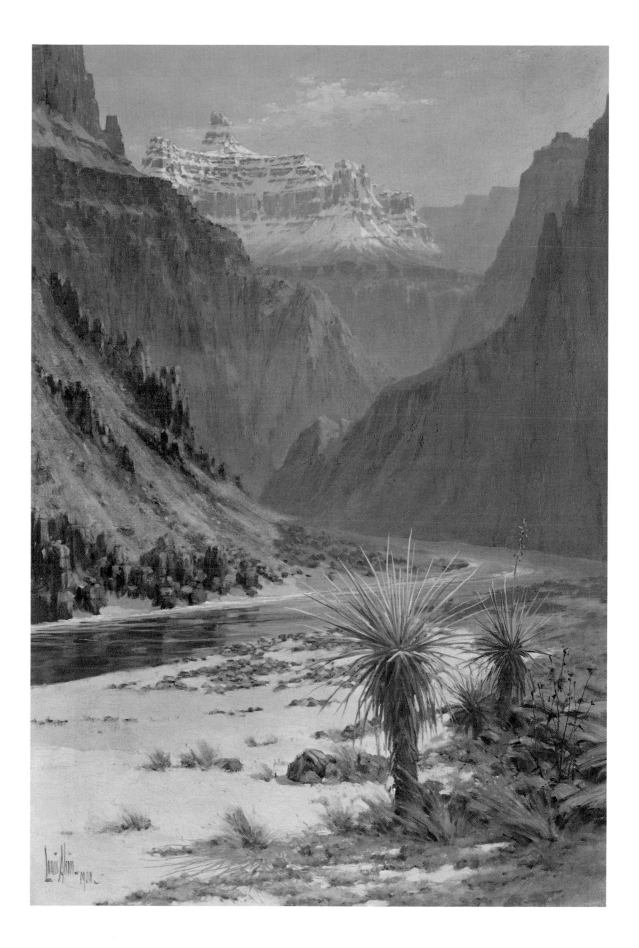

4: A Hopi Interlude

IN AUGUST OF 1907 Akin returned to the Hopi villages for his first visit since he had lived at Oraibi. This time he had a traveling companion, a 19-year-old cowboy with the CO Bar outfit named Earl Forrest. Forrest was not exactly a typical cowboy, for he was college educated and an aspiring author who had come to Arizona to record first-hand the passing of the old West.* Equipped with a Kodak and a diary, he kept a copious record of all his travels, and long after Akin's death he was able to recount their trip to the Hopi villages.

Forrest had ridden into Flagstaff from the CO Bar range on August 10th, the very day that Akin was exhibiting his big Canyon picture to the town. Since most of the range work was over until fall roundup, Forrest inquired among his friends whether anyone wanted to see a Snake Dance. But the cowboys were all headed to a horse round-up. Forrest wrote:

> Running "broomtails" was always more attractive for cowboys than an Indian dance, and so I decided to go by myself. Then Bill Babbitt, the C O Bar range boss, told me that an artist named Louis Akin, who had a studio in a room on the second floor of Babbitt's building, wanted to go to the dance, and he suggested I get in touch with him. If Akin wanted to go, Bill told me to take a couple of horses from the remuda and get a saddle for him at Babbitt's livery stable.

*It was during these years on the CO Bar range that Forrest first heard accounts of the Graham-Tewksbury feud from the older cowboys. His best known book, *Arizona's Dark and Bloody Ground,* is a detailed account of that bloody vendetta which began when a band of sheep from the Flagstaff area were herded into the Pleasant Valley cattle country.

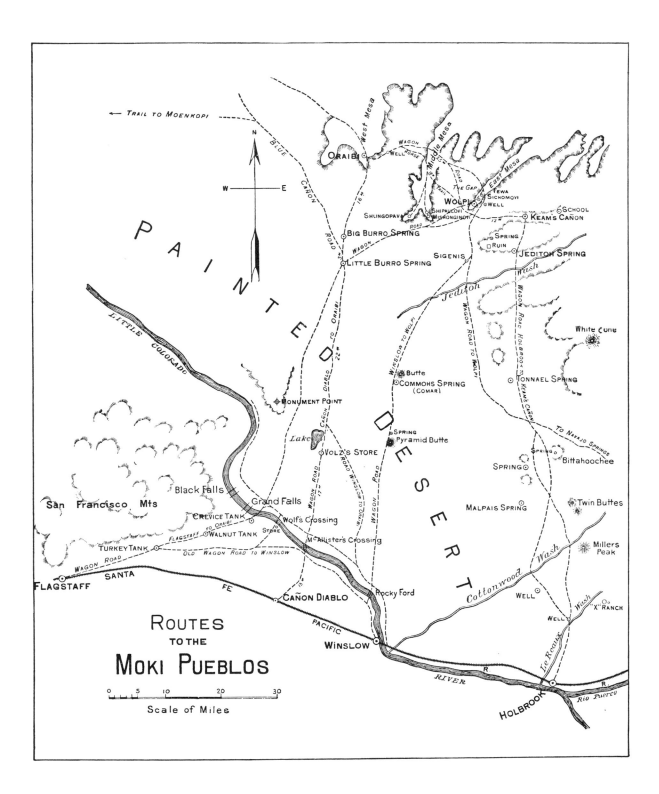

← TRAIL TO MOENKOPI

N
W — E
S

PAINTED

LITTLE COLORADO

West Mesa

Middle Mesa

East Mesa

ORAIBI

WAGON
WELL
HORSE

The Gap

TRAIL

WOLPI
TEWA
Sichomqvi
WELL

SHUNGOPAVI
SHIPAULOVI
MISHONGINOVI

Keam's Cañon
School

Spring
Ruin

BIG BURRO SPRING

SIGENIS

JEDITOH SPRING

LITTLE BURRO SPRING

Jeditoh
Wash

White Cone

WINSLOW TO WOLPI

WAGON ROAD TO WOLPI

Butte
COMMOHS SPRING
(COMAR)

TONNAEL SPRING

MONUMENT POINT

Lake

VOLZ'S STORE

Spring
Pyramid Butte

KEAM'S CAÑON

TO NAVAJO SPRINGS

Spring

SPRING
Bittahoochee

San Francisco Mts

Black Falls

Grand Falls

MALPAIS SPRING

Twin Buttes

CREVICE TANK
Wolf's Crossing
TO ORAIBI

Cottonwood
Wash

Millers
Peak

FLAGSTAFF
WALNUT TANK
Store

McAllister's Crossing

TURKEY TANK
OLD WAGON ROAD TO WINSLOW

WELL

"X" RANCH

WAGON ROAD

WELL

FLAGSTAFF
SANTA

FE

PACIFIC

CAÑON DIABLO

Rocky Ford

Te Keauts
Wash

DESERT

WINSLOW

RIVER
R.

R.

HOLBROOK
Rio Puerco

ROUTES
TO THE
MOKI PUEBLOS

0 5 10 20 30
Scale of Miles

Forrest located Akin the next morning, and the artist quickly accepted the invitation. They spent the rest of the day making preparations. Forrest recalled:

I slept that night with Louis on the floor of his room which he called his studio for want of a better name. It was littered with all of an artist's trappings. The furnishings were very meager — two or three chairs and a table. Louis' blankets were rolled up in one corner, and several pictures adorned the walls.

After an early start the next morning we followed the trail around the point of Elden Mountain, past the Greenlaw Mill, and on through the cedars east of the San Francisco Mountains. All day long we rode, and when the Little Colorado did not appear late in the afternoon we knew that something was wrong. Then we came to more open country, and I recognized landmarks. Ahead of us was the White Mesa . . . We had circled around the east side of the San Franciscos, and were far off our trail.

It was too late to return, and before dark we made a dry camp under some cedars. Louis shot a rabbit and cooked supper while I took the horses to a water hole that I knew of at the foot of a small, jagged volcanic peak of rocks about a mile away, only to find it almost dry; but there was enough to give them a taste. When I returned Louis had supper ready. That rabbit, roasted dry in the frying pan, with a can of corn, washed down with coffee, was one of the best meals I ever ate. The fact that we were both ravenous had something to do with it, for we had only eaten some drummer's lunch and a can of tomatoes at noon. We let the horses graze for a while at the ends of our lariats, and then hobbled them. As a precaution we placed the loops of our ropes around their necks and laid the knotted ends under our blankets so that they would awaken us if they took a notion to drift over the back trail and leave us afoot . . .

We were awake with the sun the next morning, and while Louis cooked our meager breakfast of coffee and canned corn I grazed the horses. That canteen was worth its weight in gold, for without it we would have made a very dry camp. We did not touch our canned tomatoes, for we did not know when we might need them for both food and drink.

That morning they rode on to visit the great Indian ruins located in present-day Wupatki

National Monument. They stopped at a large masonry tower standing atop a standstone outlier in a shallow canyon. Forrest wrote:

As we stood on the rim of the wash, Akin gazed at this tower long and thoughtfully. I wondered what he was thinking until he finally said that he intended to make a painting of it with a Hopi Indian on the rim where we were, and title it the "Home of His Ancestors." He asked me to take a photograph, but as I already had a negative I had taken once before I promised to send him a print. When I returned home that fall I sent the print. He told me later that he made the painting, and traded it to George Babbitt for a pack mule when he went to Canyon de Chelly the next year.

From the ruins we headed for the Little Colorado, which we reached in a couple of hours, only to find ourselves on the rim of a canyon with the river and water far below. After some search we found a way down; but the water was a deep red-brown, and so impregnated with sand that the horses would not drink. We finally found a pool along the shore where the sand had settled and the water was almost clear. The horses drank, and after filling the canteen we started up stream. All day long we traveled along the river. Many times we had to ford or climb out to the rim where the river ran close to the cliffs. Finally we reached the end of the canyon at Grand Falls, and camped for the night.

The next morning we resumed our journey; and a short distance above the falls we came to the ruins of Wolfe's Store, half buried under the drifting desert sands. This was an old-time Indian trading post that had been abandoned several years before; and painted on a board above the sand filled doorway we read in faded letters, "Wolfe's Trading Post." The stone walls of the store building, built like a fort in the days when the Navajos might not be too friendly, were all that was left of this once famous trading post of old Arizona.

Just above the old trading post we came to a Navajo camp, where Louis persuaded two of the men to pose with him for a photograph. They told us in broken English that Tolchaco was just up the river; but it was an hour before we reached this long sought mission on the banks of the Little Colorado. As I remember it there were only three buildings — a combined church and house

MESA AND DESERT 1905 oil, 30 x 36

Collection of Mrs. Herbert Babbitt

for the missionary, a trading store operated by David Ward and his wife, and their small dwelling, with a couple of corrals and stables.

As soon as the missionary, whose name I have long forgotten, heard our story he invited us in, fed our horses and gave us our first real meal since leaving Flagstaff. And of all things to find in the desert he had a bathroom with a real tub and running water from a tank under the roof. He placed this at our disposal, and how we did luxuriate. He offered us beds for the night, but we preferred to sleep outside and camped in an abandoned Navajo hogan. It was very large, having been built for a ceremonial lodge, and there we spent a comfortable night.

As it was Wednesday, August 14th, when we arrived at Tolchaco, we decided that we could not make Walpi in time for the dance the next day, and so we decided to start the next afternoon for Mishongnovi where the Snake Ceremony would take place on Sunday.

Two men working at the mission decided to go with us, and late Thursday afternoon we set out for the Fields, Fred Volz's abandoned trading store on the road to Oraibi. It was only fourteen miles, so we were told; but they proved to be "cowboy miles." Darkness overtook us while we were still on the trail, and it was soon so black that we could not see. I took the lead and gave "Old Smut" his head. How that horse followed that trail I will never know, but before long we were right at the old store building.

Traveling light has one big advantage — it does not take long to make camp. In a few minutes we had gathered enough sage and greasewood to make a fire; the coffee pot was boiling, and we hungrily ate the sandwiches Mrs. Ward had given us before we left.

We had just crawled into our blankets when an orange-red disk suddenly came up from behind the far-away rim of the desert, and the whole land was bathed in the silvery light of the moon. Louis and I sat up and watched, drinking in all the beauty of the scene as the great orb rose higher and higher. The adobe walls of the old store building stood out in the white light with just enough dark shadows to add to the intense beauty, and the cottonwood trees that Fred Volz had planted long ago fairly gleamed in the silvery brightness. I thought then and still think that the moon rising on the desert at the Fields

that night was one of the most beautiful sights I have ever seen. It was a picture I have preserved in memory with every detail all these years.

"Did you ever see anything like that?" Louis remarked almost in a whisper as though he was afraid to break a spell. "Some day I'll paint it, with the old store against the sky and those cottonwoods bathed in that silvery light, and the Vermillion Cliffs away off to the left."

The next night we camped a little beyond Big Burro Spring, and about noon Saturday we reached Toreva Spring at the foot of the Middle Mesa, just below Mishongnovi.

There they watched an Antelope Dance just before sunset. The next morning they were up at sunrise and went to the edge of the mesa with a crowd of Indians to watch the contestants in the Snake Race (a ceremonial foot race) gradually straggle up the mesa from the desert below. Forrest relentlessly photographed everything in sight, and Akin steered him to the Snake Kiva for a snapshot of the winner receiving his prize of several prayer sticks from the Snake Chief. Akin later did a painting of the scene.

They passed the remainder of the day before the Snake Dance exploring the mesa tops outside the villages. When they came upon a deep crevice at the edge of a mesa, Akin related a story told to him during his stay at Oraibi. In 1898, a smallpox epidemic had swept through the villages, devastating the inhabitants of Mishongnovi and Shipaulovi. The Indians perished in frightful numbers, and the bodies of the dead piled up in the streets because the terrified survivors refused to go near. Finally the Indian agent had called in a detachment of black soldiers from Fort Wingate, and a mass cremation was ordered. The bodies were then gathered and thrown into the crevice, covered with oil and burned. Over the years drifting sand had covered the bones, but upon venturing into the crevice Akin and Forrest discovered bleached fragments of bone protruding through the sand and numerous ceremonial offerings. Akin then noticed a Hopi silently watching them from the top of the crevice, and they promptly terminated their exploration.

Late in the afternoon they crowded onto the terraced rooftops with several hundred Indians and five whites to watch the Snake Dance. The mood induced by this ancient thaumaturgy for life-giving rainfall is difficult to capture; Forrest wrote simply, "The uncanny incantation of the antelopes, the steady clanking of their rattles, dancers going

41

POOL IN THE DESERT 1910 oil, 24 x 14

Collection of Mrs. Thomas E. Pollock

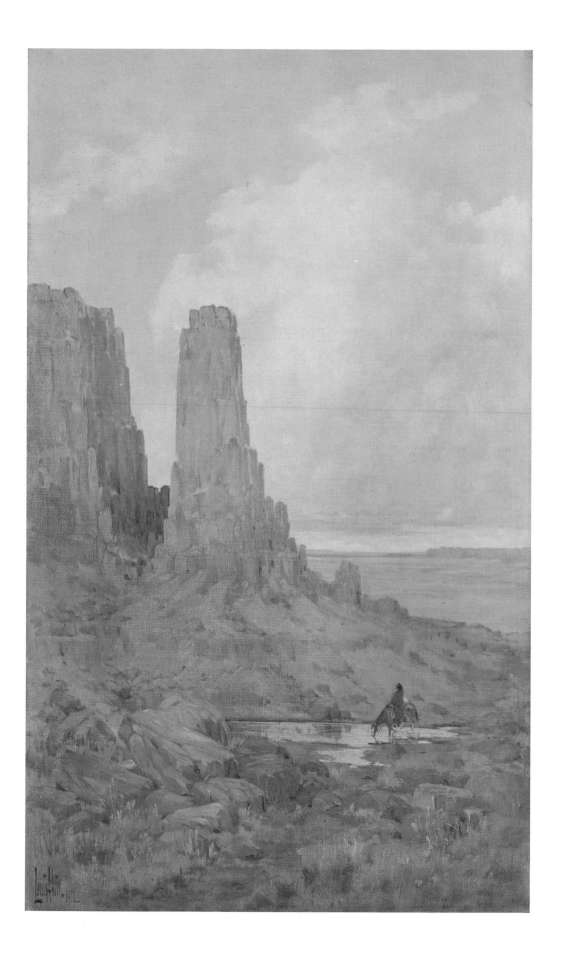

around with deadly rattlesnakes held in their mouths and the gatherers with their hands filled with serpents made a scene never to be forgotten."

The next morning Akin and Forrest rode across to Oraibi on Third Mesa to watch the Flute Dance. But Oraibi was no longer the vital center of Hopi life that Akin had experienced and written about just four years before. The great village had been split by internal dissension and was already falling into ruin. The longstanding clan rivalries and conflicts between the friendly and conservative factions had steadily developed to a breaking point that climaxed in the summer of 1906. The Snake Dance that year was delayed until September 5 while the two factions quarreled over ceremonial prerogatives. Then on the following day sporadic street fighting broke out and for a few tense hours it appeared that Oraibi would erupt into an all-out civil war. Finally, however, the leaders of both factions were persuaded to accept a peaceful solution: one faction would have to leave Oraibi forever. The leaders agreed upon a test that would be a sort of reverse tug-of-war. A line was drawn and the two factions drew up and pushed; the struggle for possession of the greatest pueblo in Hopiland raged on for several hours. Finally the exhausted conservatives collapsed, and amidst portents of doom and fulfillment of ancient prophecies, they filed out of Oraibi with their possessions to search for a new home.

Akin and Forrest watched the Flute Dance, Forrest taking pictures while Akin watched the ceremony intently. The following day they roamed about the streets of the half-ruined village. Forrest recalled one moment of levity in an otherwise depressing scene:

> A few minutes later a Hopi man ran into the plaza, one hand held high with some object in it, and a group of young women were chasing him. He dodged and ran from one point to another until they finally captured him and secured the coveted object. When Louis asked what was going on they told him that it was *mochiota*, a sort of jollification following the Flute Dance. A man would run with something in his hand, and the women would chase him until he was caught.
>
> That was enough for Louis Akin. He suddenly held up his hand and started to run, and instantly the women and children were in pursuit. When they finally cornered him on the roof of the kiva, he fished a bag of candy out of his pocket and gave it to them.

Many of Akin's friends were among the conservative faction that had left Oraibi on that fateful day in 1906, and he resolved to visit their new village, Hotevilla. So he and Forrest purchased supplies at the Oraibi Trading Post and set out on the short ride west to Hotevilla. Forrest related their experience:

Before we started the trader at Oraibi told us that they were in destitute circumstances, and we purchased a gunny sack full of coffee, sugar and canned goods for presents. A Hostile at the store volunteered to guide us. As we neared the village we came upon a group of children playing, as children always do when they get together; but the instant they saw us they scampered through the sage brush like scared rabbits, crying "bahana, bahana." They were afraid we were soldiers coming to take them to school which had closed for the summer. Even though our guide assured them that we were friends they gazed fearfully at us as we rode into Hotevilla.

Most of the people welcomed us; but a few held aloof, and our presents of coffee and canned goods were turned down with scorn. They wanted nothing from the white man. But Louis' friends greeted us with open arms, and when we left we did not carry back a single item.

The courage of those Indians won our admiration. Hotevilla at that time was very primitive — only a few stone houses and brush wickiups. The latter were pleasant in summer but a poor shelter for winter. The inhabitants were in such destitute circumstances that we did not see how they would last. Their crops had been burned out, and many of their sheep had died of scab; but still they refused to return to Oraibi. They wanted nothing from the government. All they wanted was to be left alone to live their religion and their ancient customs, and for this they suffered deeply. Too proud to ask for help, even from their kinsmen at Oraibi, they eked out a miserable existence. . . .

From Hotevilla Akin and Forrest returned to Oraibi, spent the night, and then retraced their way back to Flagstaff with overnight stops at the Fields, Tolchaco and Greenlaw Mill. There hadn't been any rain at the Snake Dance, but a drenching rainstorm caught them as they rode toward Tolchaco.

A year later, in August of 1908, Akin returned to Indian Country. The interven-

45

ing winter had been particularly frustrating: the big Canyon picture had been rejected by two exhibitions, the Stanton project had come to nothing, and sales had been even slower than usual because of the financial panic of 1907. Eager to get away, he planned an extended trip through the Hopi villages and eastward to Canyon de Chelly in Navajo Country. He made the trip riding alone; Forrest, returning from a trip to the Hopi villages, encountered him on the trail near Greenlaw Mill "riding a horse and leading a mule well packed with provisions and artist's supplies." Akin paused for a week at Oraibi, and again visited Hotevilla where he must have been gratified at the progress his plucky conservative friends had made in building a new pueblo and re-establishing their ceremonials. He stayed to watch their first Snake Dance, then resumed his trip to Canyon de Chelly, stopping at Shipaulovi on Second Mesa long enough to meet a friend, Frederick Monsen, the Indian photographer, and to witness another Snake Dance. It was an unusual and dramatic event which he described in a letter to Forrest: "When it began to rain about two o'clock in the afternoon, the Snake priests became wildly enthusiastic, and when it developed into a terrific downpour about three o'clock they could stand it no longer. They fairly jumped out of the Kiva, and held the dance in a heavy rain, with lightning flashing and thunder rolling."

From Shipaulovi he went to Walpi on First Mesa where, sick from drinking contaminated water, he rested for a week. He then rode through Keams Canyon to Ganado, the great trading post complex which was still operated by the legendary Lorenzo Hubbell, Navajo trader, politician, friend of Theodore Roosevelt and patron of Western artists. Akin was exhausted and still sick. At Don Lorenzo's insistence he rested for a week before setting out alone for Canyon de Chelly with replenished supplies and a fresh packhorse.

He spent about ten days in Canyon de Chelly riding through the Navajo orchards and cornfields, sketching the massive sandstone walls and cliff dwellings. One of the oil sketches, a lovely view of Spider Rock from the Canyon floor with a Navajo rider passing by in the distance, went to Don Lorenzo, probably as a gift for his hospitality. A letter to Don Lorenzo survives, written several years later, in which Akin sent another painting, of a Hopi Drummer, as a gift. He wrote, "After many years this is a mere crumb floating back to you from your many loaves of well buttered bread cast upon the waters." He added that he would soon provide another painting in exchange for some Navajo blankets given to him by Don Lorenzo. These three paintings, a part of Hubbell's

46

extensive collection of western art, still hang on the walls of the old Hubbell home at Ganado, now a National Historic Site.

Some months later, back in New York City, Akin had an opportunity to reflect once more on his Hopi experiences while preparing a preface for a *Craftsman* series by Frederick Monsen lamenting the destruction of Indian cultures. Akin's exposition of Monsen's ideas undoubtedly reflected his own thinking as well:

> Of all the ideas he [Monsen] advances as the result of his long experience with Indian capabilities and characteristics, none is more vital than the position he takes with regard to the destruction of the ancient crafts and the attempt to replace them by modern commercial work that is practically valueless as well as hideous and commonplace. Mr. Monsen holds that if the Government would send to them instructors who would exercise some intelligence in reviving and preserving the wonderful old handicrafts of the peaceful tribes, instead of giving the children instruction in the trades and industries of the white man, the Indian would not only take more kindly to the white man's idea of education, but it would be a great deal easier for him to earn a living. More than this, Mr. Monsen holds that in the preservation of the Indian crafts, as well as Indian traditions, games, ethics, morals and religion, there lies a strong influence for good that would ultimately affect our modern art and life.

HOPI SNAKE PRIEST 1904 oil, 24 x 14

Collection of Mr. and Mrs. Robert Veazey

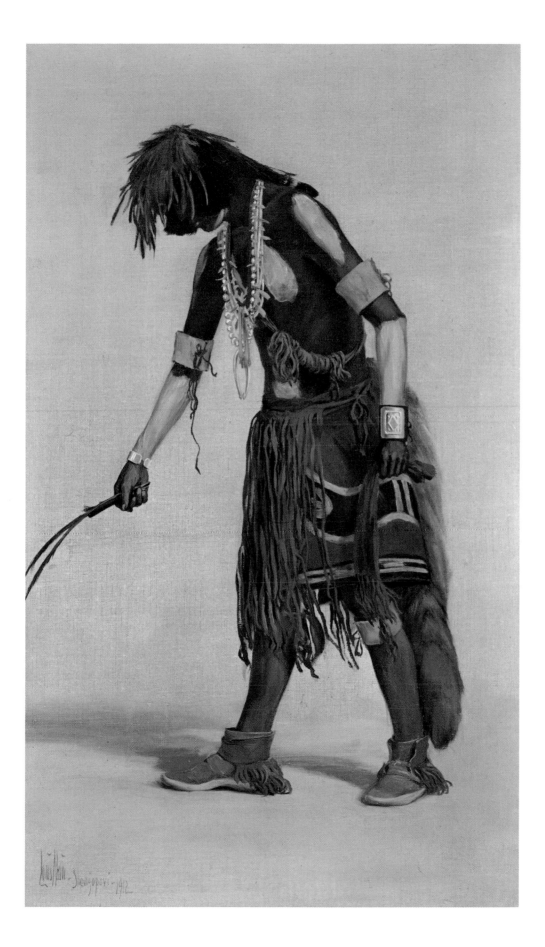

5: Alpine Apotheosis

IN THE AUTUMN OF 1908 Akin's friends in Portland arranged for an exhibition of his work in his home town. He returned to Portland for the showing, apparently his first visit since he had left for New York City in 1897. The exhibition ran through September and October, and both Akin and his paintings got a warm and sentimental reception.

The *Oregonian* declared:

Few of the many art lovers of Portland are aware that a collection of pictures which has attracted the greatest attention throughout the art centers of the United States, has been on exhibition here for the past two months. . . .

Not all of those who have seen the pictures know that a Portland boy painted them, and that he has won for himself a high place in the field of art. Many of the artist's old-time friends and acquaintances are today marveling at the work of the man who, through his determination and perseverance, and above all, hard study, has earned for himself not only the admiration of his fellow workers, and of everyone who knows him, but the distinction of being one of the foremost landscape painters of America.

That visit to Portland reawakened his interest in the Pacific Northwest where he had spent so much of his boyhood roaming among the mountains and lakes. He returned the following summer for a trip to British Columbia with his childhood friend, Robert Warner, who was now a Boston stockbroker. Warner's objective was to hunt mountain sheep, Akin's to paint, but both were resolved to travel to remote and unexplored areas. First, however, they went from Vancouver by railroad to visit Canada's Glacier Park in the heart of the Selkirk Mountains. Akin wrote of that journey:

Through my entire life of intimate association with the big things of the West I have felt that sometime I should go to the land of the Canadian Rockies and the Selkirks, and that I should find there the apotheosis of all mountain scenery, my ultimate goal of beauty. And as a reward for my faith in the kindness of Fate, I found myself this last summer out in the midst of those great mountain peaks, knowing them by name, feeling familiar with them, yet not even stopping to pass the time of day. For having reached the goal of my desire, I realized that my interest had passed beyond, and that I was headed for that place marked on the Canadian maps as "Mountains and Glaciers." I was going to Lillooet, to a land of things utterly primordial and unpublished.

Akin and Warner did pause long enough in Glacier Park for Akin to paint several pictures, including a view of Mount Sir Donald located in the middle of the park. But both travelers were intent upon discovering more primitive areas, so they then took the train back toward Vancouver as far as the Fraser River where they then went north by stagecoach. Akin wrote of this adventure:

Clinging to the walls of a magnificent gorge breaking down through the western foothills of the Rockies, the railroad on which I was traveling suddenly turned out into the great valley of the Fraser, the River of Gold from the far North. From here my way lay northward fifty miles by stage, and all through mountains, vast mountains on every side. They piled up, height upon height, on both banks of the river — some precipitous, naked, awful, some gentler of contour, clothed in a green velvet of spruce and pine, and everywhere, the great walled heights streaked and patched with snow; through an occasional break in the outline, still higher, masses of glaciers clinging to their breasts.

. . . Surrounding these mountains in every direction is the most ideal out of door lands. Anywhere above five thousand feet you may ride freely; there are magnificent leagues of park-like country, all aslope one way or another but easy or steep, your tough little cayuse will carry you over it, up, down or crosswise at a run, if you let him! Game is plentiful, big and little; trout are in every stream and lake, and wood, water and grass are everywhere. The days are hot and the nights are cool, even snappy. It is that most fascinating zone

51

MOUNT AKIN 1909 oil, 12 x 16

Collection of Mr. and Mrs. Jack Verkamp

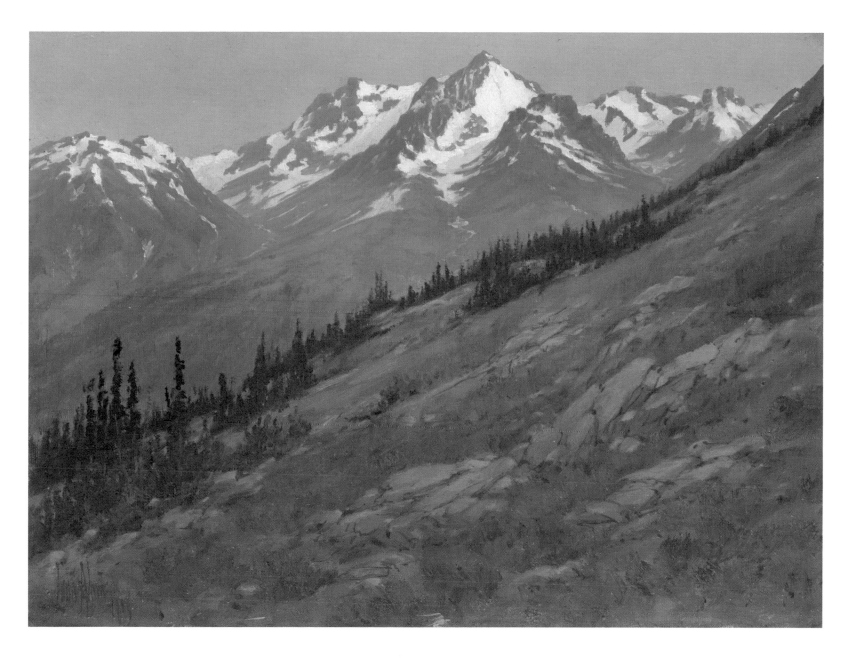

where the Alpine spruce groups itself in its most picturesque way — its clusters of spire-like tops broadening out at the base into a well-nigh impenetrable hedge, that, surrounding an entire group of trees, offers safe and sheltered haven in time of storm to the wild things of the highlands.

High up are emerald green lakes that defy the palette, some at the very foot of glaciers and bearing gleaming icebergs on their placid bosoms; some lower down, set in warm green meadows with spruce-green backing; some washing the base of cheerless granite heights, black and barren. And everywhere are flowers ripe and luscious wild strawberries — all in September and October. Spring is always here, except when winter is: spring grasses and blossoms follow the retreating snowfields right up the mountains, and highest of all, blooming and living its brief life in evident happiness, is the forget-me-not, rooted in the ice-cold moisture not a yard from the snow's edge. . . .

Warner spent most of his days hunting mountain sheep, while Akin, stimulated by the change of climate and scenery after six years of the Arizona desert, painted voraciously. For the *Craftsman*, a national art magazine, he did a two-color watercolor illustration of an azure mountain lake surrounded by glaciers. He painted an unnamed mountain peak and entitled it *Mount Akin*. Several other paintings went to Warner who later described one entitled *Jack's Valley*:

. . . I cherish in my own home many of his sketches in pen and in oils, covering a period of twenty years — everyone breathing a breath of wild, and culminating with his masterpiece, *Jack's Valley*, in a splendid canvas depicting a late afternoon view across this valley toward Jack's Mountain and the glaciers, which flashed at right and left on the horizon — a very wonderful spot, the site of the furthest camping ground of our sheep hunt in 1909.

When not painting, Akin spent his time getting acquainted with the Lilooet Indians who inhabited the valley. Warner subsequently recalled Akin's easy manner among the Indians.

. . . The Indians always seemed to find in him a kindred spirit. He saw nature

with the eye of the Indian. He would pick up a new Indian language with amazing rapidity, and was always teaching the Indians words from other tribes. In two weeks' time, while sheep hunting in the Fraser River cascades four years ago, he had taught Jack James of the Lilooets a good part of the Hopi language, and they were constantly flinging Hopi expressions at each other to the great amusement of old Napoleon, who sat grimly by the fire, occasionally croaking with delight.

At the end of the summer Akin returned from Vancouver to New York by taking a train across Canada to Quebec. In Quebec he called upon the Canadian railroads seeking commissions for more work in British Columbia. While in that city he wrote to a friend from Chateau Frontenac, praising the Canadian Rockies, but admitting that the Grand Canyon was still his first love:

. . . there's some great stuff untouched there till I touched it. It's a truly wonderful section — you could lose a dozen Switzerlands in it and it's full of beauty in many ways — but I don't believe the most inspiring of it can bring to one anything like the awe that the Canyon inspires — it can't hold one indefinitely as the Canyon can. At least that's my feeling, and snowclad mountains with their environments have always been the greatest things in the world to me, excepting the Canyon.

The following summer he returned again to the Pacific Northwest, this time to the newly established Glacier National Park in Montana. Little record remains of his travels or of the paintings made during that summer. Very likely they now are scattered throughout the United States, owned by descendants of Akin's friends and admirers.

6: Sunset and Afterglow

THE LAST YEARS OF Akin's short life were colored by personal disappointment. Sometime after his fortieth year, probably in 1910 or 11, he finally married. His wife, Mai Ritchie, was a Philadelphia girl who had taken art lessons from him at Flagstaff or the Grand Canyon. They began life together in Arizona by designing and building a home, isolated in a dense stand of yellow pine just north of Flagstaff. For a time Akin consumed his energy in drawing plans and supervising construction.*

But the marriage did not work out and he became increasingly moody, stopped painting and for awhile did nothing at all, leaving his city-bred wife to milk the cow and run the household single-handed. The isolation and discomfort of northern Arizona must have contributed to the stress, and the marriage soon ended. She returned to Philadelphia, and Akin never spoke a word of this painful episode. Years later, no one in Flagstaff could remember much about Mrs. Akin, except that she kept a pack of greyhounds which repeatedly devastated the neighbors' yards.

By the summer of 1911 Akin had recovered his composure and again turned his energies to painting the Southwest. The catalyst was a commission from the American Museum of Natural History in New York City to paint the murals for its new hall of Southwest Indian life. In a letter to Simpson, his friend at Santa Fe Railroad, Akin explained the commission: "A whaling big mural commission for New York City is going to keep me humming for 4 or 5 years — and I think Santa Fe ought to subsidize me for it

*The site is now occupied by the residence of the Director of the Museum of Northern Arizona. It was acquired by Akin in 1908 from a friend, Hayden Talbot, who had constructed a small residence, reportedly from plans provided by McKin, Mead and White of New York City. Akin had assisted Talbot in the design and construction of a great tufa stone fireplace that was the central feature of the house. After his marriage Akin enlarged the house; it was subsequently destroyed by fire in 1928 and later rebuilt around the original stone fireplace.

too. It's all Southwest Injun — all the way around a hall 65 x 140 feet — 16 separate panels — one Grand Canyon 9 x 65 feet — one Canyon de Chelly same size."

In August he left Flagstaff and went out to the Hopi villages to begin sketches for the murals. He visited his friends in the different villages and went to Walpi on First Mesa for the Snake Dance. Shortly after the Snake Dance he contracted dysentery. The illness was so severe that he was unable to muster enough strength to travel back to Flagstaff, and he languished on the Reservation for a month before returning to town where he spent another month recuperating.

A few months later he was sufficiently recovered to travel to Phoenix to enter a special exhibition of his work in the Territorial Fair and to act as a judge. By now he was well-known in Arizona, and the exhibition received favorable comment in the press. After the fair closed his own exhibition was moved to the newly rebuilt Adams Hotel for another showing.

In December he was back at the Grand Canyon to begin work on sketches for the Grand Canyon mural required by the American Museum commission. Thomas Moran, the aging patriarch of Canyon painters, was at the South Rim with a group of Western artists, and Akin wrote that they had "a bully visit." For the Museum commission, he did a 4-1/2 by 30 inch watercolor panel of the Canyon, scaled to the 9 x 65 foot mural to be completed in New York. While at the Canyon, Akin also completed a large and notable painting of the sunset from near Yavapai Point. The 2-1/2 x 7 foot canvas includes a vast sweep of the eastern Canyon from Zoroaster Temple across to the walls of the Little Colorado and back to Yaki Point. Bright colors and strong contrast are used more adventurously than in previous paintings. In the foreground the Inner Gorge is submerged in night hues of purple and blue, while in the background sunlight floods across Zoroaster Temple and lights the background in impressionistic shades of orange and yellow. The painting, one of his last of the Grand Canyon, suggests movement toward a less restrained, freer style of landscape painting. Akin himself recognized this trend in a letter describing a painting entitled *The Temple* painted at about the same time. He described it — almost apologetically — as a "sunset from way out on the 'battleship' with Zoroaster as the center of interest — a strong foreground of dull red rock and primrose trees. It's a corker — rich in color but not absolutely true as to conformation — a bit idealized but absolutely characteristic."

A few months later, unknown to Akin, the Fred Harvey Company and Santa Fe

THE TEMPLE 1912 oil, 24 x 24

Collection of Santa Fe Railway

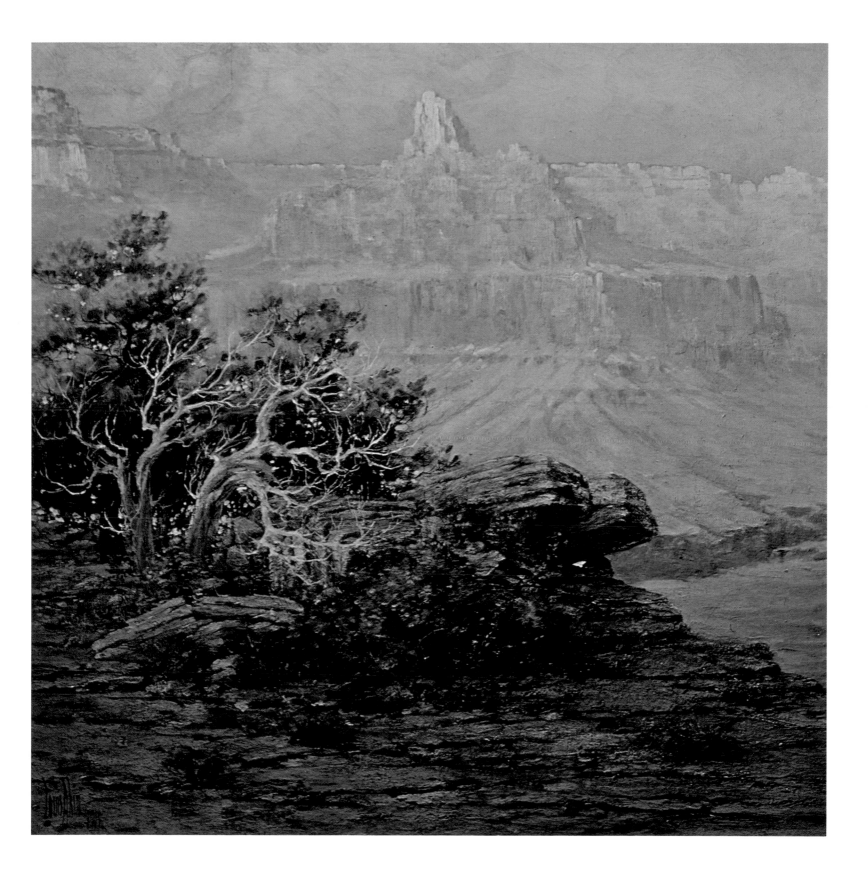

became entangled in a small crisis over an Akin watercolor labelled — or mislabelled as it turned out — *Mohave Woman with Olla*. The main protagonist was J. F. Huckel, a strong-willed Harvey in-law in charge of the Company's curio business. Huckel and Akin had been at odds before; on one occasion back in 1907 they had had a prolonged argument concerning whether Akin's commitments to Fred Harvey precluded his use of a studio at Verkamp's, Harvey's principal competitor at the Grand Canyon.

Supai Woman

The *Mohave Woman* tangle began in January, 1912 when Fred Harvey paid $50.00 for the rights to reproduce Akin's *Mohave Woman* watercolor on post cards, Santa Fe menus and in an album of Indian portraits then in preparation. Several months later Huckel happened to write Santa Fe explaining that Fred Harvey had been unable to locate any paintings of Supai Indians for the Indian album. Huckel asked if Santa Fe had any Supai photographs that could be used in place of a painting. Santa Fe responded by providing several photographs of Supai Indians taken by George Wharton James. Everyone noticed a surprising coincidence — one of the Supai photographs was virtually identical to Akin's *Mohave Woman*.

Huckel angrily wrote to Santa Fe accusing Akin of plagiarism: "I have the reproduction of the *Mohave Woman* before me and instead of being similar, Akin's painting is an exact reproduction of Mr. James' photograph, even to the very smallest detail." Huckel's letter conceded that "Akin's water color is much more interesting for the fact that it has the metate and carrying basket in the foreground," and went on "As we have already reproduced this picture for the Indian album we will change the title to *Supai Woman* instead of *Mohave Woman*."

But Huckel was so irritated that he decided to drop Akin's name from all reproductions of the painting. He wrote, "In our menus which are just about to be printed I

believe we have this *Mohave Woman,* as you know, in color with the words 'After Akin' . . . I would rather prefer not to give Akin the credit for this painting when the original belongs to Mr. James."

Santa Fe responded with a tactful suggestion that "If you reproduce Akin's painting for the album, it might add to the advertising value to include the name of the artist." But Huckel was not to be placated, and Akin's name was removed. When the Fred Harvey Indian album, *First Families of the Southwest,* was finally published, the picture appeared as *Supai Woman* and the painter was not identified. Whether Akin himself ever learned of Huckel's discovery, and how the *Mohave Woman* came into being is not known.

The summer of 1912, the last summer of Akin's life, was a productive period. His energy and enthusiasm for painting was at a peak and he quickly turned from one project to another. In July Simpson wrote from Chicago that he was planning a trip West and might stop off at Flagstaff for a visit. Akin had not seen much of Simpson and Santa Fe since the railroad had rejected his big Canyon picture in 1909, but he now welcomed the chance to renew the friendship. He responded with an invitation from a committee of local citizens to visit Flagstaff and the surrounding area. Simpson arrived in August and spent a full day touring around the San Francisco Peaks and Sunset Crater with the citizens' committee. Tourism was uppermost in the committee's thoughts, and before leaving Flagstaff Simpson expressed his views on that subject to a newspaper reporter:

> The San Francisco Peaks are the one great attraction and do more to advertise Flagstaff to travelers than any other thing, because they stand out for themselves. I have engaged artist Akin to paint three pictures of them to be placed in our large Eastern offices.

The San Francisco Peaks had become one of Akin's favorite subjects during his years in Arizona, and he worked on the commission with such enthusiasm that the three paintings were completed and shipped to Chicago within a month. Santa Fe paid him $100 for each of the paintings. The best of the three, a view of the Peaks through an afternoon rain shower, was painted from a place close by his home north of Flagstaff. It was used many years later to illustrate the 1948 Santa Fe calendar.

After finishing the Santa Fe commission he set out again for the Hopi villages to

SAN FRANCISCO PEAKS 1912 oil, 28 x 40

Collection of Mrs. Margaret Dow

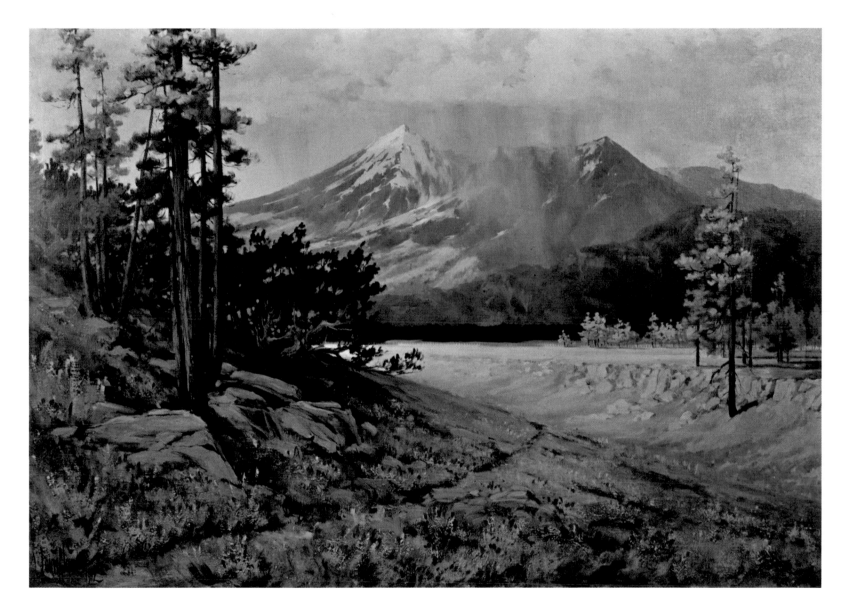

make up the work that had been cut short by illness the previous summer. This time he left the horses behind and traveled with a group of Flagstaff friends in a new motor car that cut the trip from three days to six hours. But he confessed mixed feelings, writing, "I feel like a degenerate — to be going to the desert in a motor car! But I must admit its utility as a time and labor saver."

The party stopped first at Oraibi for the Snake Dance. He found Oraibi "unfamiliar in its deserted and broken-up condition" and wrote that the Snake Dance was a "fizzle" because the Antelope Clan had all deserted to Hotevilla. He also noted that the Antelope Dance, now performed by the snake priests in the absence of the Antelope Clan, had been transformed into a different ceremony: "[The dancers] pulled off a queer stunt the evening before — dividing the ten snake men and singing the usual chants, carrying two snakes in their mouths in the place of the usual corn."

From Oraibi he went to Hotevilla where he found a remarkable resurgence and vitality in contrast to the decadence and decay at Oraibi. The struggling new village that Forrest had described five years before as a miserable collection of brush wikiups and primitive stone shelters had been transformed into a thriving pueblo with neat stone units laid out around plazas and kivas. Crops of corn, chiles, and melons were ripening in the fields, and the plazas and kivas were coming alive with the old ceremonials in their purest and most traditional form.

The Hotevilla Snake Dance, he wrote, "was all fine as could be." He noticed a new feature in the dance "being the Antelope men painted in bright blue all over — with the usual white markings on them. They say it is a proper old custom but they have not had some of the paint for many years — some men made a trip to Grand Canyon recently and got it. It was very effective."

Akin searched out the old chief, Yukioma, whom he had known at Oraibi in 1903 before the exodus to Hotevilla. He asked Yukioma's permission to live and paint in Hotevilla for a few weeks. But Yukioma and his followers had had too many bitter experiences with white men to make any exceptions — even for an old friend. Just the previous fall, in the continuing dispute over schooling of Indian children, the resident Indian agent had called in a hundred cavalrymen and forcibly removed all children of school age from their hiding places in the pueblo. Yukioma, passive but defiant, had been jailed for several days.

Akin wrote of his meeting with Yukioma, "While expressing the greatest friend-

64

ship and regard for me personally and acknowledging his people feel likewise; he was adamant to my desire to live there a few weeks to work. He says it would be establishing a precedent and if he let me come, he couldn't keep the others away."

In the coming year Yukioma was to be imprisoned again (this time for five years) by the Indian agent who considered him "a deluded old savage, possessed by the witches and Kachinas of his clan, living in a lost world of fable . . . the last of the Hopi caciques."

Akin reluctantly left Hotevilla and finally settled upon Shongopovi, located across Oraibi Wash on the tip of Second Mesa, as a place to work. Shongopovi was nearly as conservative as Hotevilla in its adherence to the old ceremonial ways and antipathy to the white man. Perhaps for that reason, Akin rented a small building just north of the main village. He wrote to Simpson describing his new residence:

> I have a "bungolette" about 150 yards back of the village quite isolated and with a wonderful outlook south to the masses of the Moqui Buttes and westward to the San Francisco Peaks which seem to fill the entire horizon at times. On the other sides we look down on Oraibi and all beyond it and eastward over Shipaulovi and Mishongnovi, on over Walpi and clear away to distant mesas beyond Chin Lee and Ganado.

He added, "I wish you could help me clean out a pot of beans that are beginning to smell mighty good! Incidentally, there will be a rabbit for supper and watermelon and piki! Plenty good eating now — fat lambs, peaches, squash, green beans, corn and cantaloupes."

He remained at Shongopovi for about two months to make up for time lost by the dysentery attack the previous summer. It was his first extended stay in Hopi country since he had left Oraibi in 1904, and he painted prolifically. Some of his Shongopovi work, paintings of weavers, corn grinders and other domestic scenes, is reminiscent of his earlier work at Oraibi, although somewhat stronger in composition and improved in treatment of the human figure. The most interesting of the domestic scenes is a watercolor sketch for the mural project, depicting a hunter returning home with the day's kill of rabbits to receive the traditional corn meal blessing.

But this time Akin turned more of his attention to the rich pantheon of Hopi ceremonial objects. He completed two oil portraits of snake priests, possibly intended as studies for a full scene from the Snake Dance. Perhaps the most interesting painting

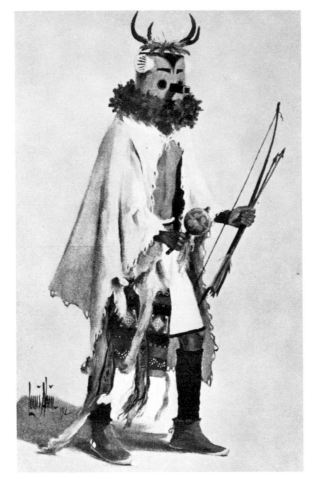
Buckskin Kachina in dance costume

from this trip is his *Buckskin Kachina*, a carefully detailed color sketch of a live Kachina impersonator. Little is known of this ancient Kachina from the ruined village of Awatovi and his painting and description of the Kachina's function are the most complete data now available. Akin described how he happened to obtain the picture and the significance of this particular kachina: "This kachina has not appeared in public for many years, and I had some difficulty in getting details. He finally consented to pose for me however, but without the headpiece, giving me permission to make drawings of that. It would be very sacrilegious to wear any Kachina mask outside the proper ceremonial occasions. It is a sketch in color — really a very correct 'study' of the character. He is known as 'So-we-ing-wa Ka-chi-na' and is one of the many demigods of the Hopi Indians. 'Soweingwa' means 'deer' and is also the common term for 'buckskin.' He is the patron saint of the hunter and is a protector of game from natural enemies. With his rattle he warns of the approach of such as wolves and mountain lions, and with his trusty bow and arrow he slays the same when opportunity offers. With his song he soothes the nerves of game animals with appeals to their vanity and comforts them with the assurances of the very great good and happiness they will be conferring on the Hopi by their death." Shortly after completing the painting, Akin gave it to the Campfire Club, an outdoor organization in New York City to which he belonged. It has since disappeared and only black and white reproductions survive.

In November Akin left Shongopovi and stopped at Canyon de Chelly to prepare

a 4-1/2 by 30 inch watercolor panel as a companion to the Grand Canyon panel. He then went to Zuni pueblo in New Mexico to watch the Shalako dances and make sketches and gather additional materials for the American Museum murals. He stayed about three weeks and completed at least four studies of Zuni Kachina dancers. But there was not enough time to sketch everything he needed, and he resolved to obtain photographs of the Shalako dance even though the Indians had banned picture-taking. Earle Forrest later learned of Akin's solution and described it thus:

> In 1912 I received a letter from Jim Harvey of Santa Fe, an old friend of my college days, who was surveying on a government dam at Zuni. At the Shalako in Zuni he saw a man, dressed in a rather large corduroy coat and cavalry boots, watching the ceremony very intently. Jim noticed that he kept his right hand in his coat pocket, and there was something in that pocket that made it bulge. Occasionally he would grasp the pocket with his left hand for a few seconds, but he never removed his right hand. He viewed the picturesquely attired participants from all sides, and Jim wondered what the man was doing. Finally, the stranger approached Jim, and they engaged in conversation, mostly about the dance. The talk finally drifted around to themselves, and the stranger introduced himself as Louis Akin, an artist from Flagstaff. . . .
>
> Photographs of the Shalako were absolutely forbidden by the Zunis, and Akin confided that he had a small Kodak concealed in his coat with a hole cut in the pocket. He had practiced and knew just how many turns to make after each exposure.

Shortly before Christmas he returned to Flagstaff to make preparations for a trip to New York to show his sketches at a February exhibition at the American Museum. However, a few days before Christmas he became ill and was soon in the town hospital complaining of a chest cold from exposure. Pneumonia developed rapidly, but, not wanting to alarm his friends, he did not ask that anyone be notified. By December 28th his condition had become grave, and he requested to see Thomas Flynn, a local attorney with whom he had shared an apartment for the previous year. Flynn came to the hospital and found him breathing heavily and alternating between delirium and lucidity. Akin attempted to will his entire estate to Flynn, expressing doubt that anything would remain

THE RIVER 1908 oil, 30 x 20

Collection of Santa Fe Railway

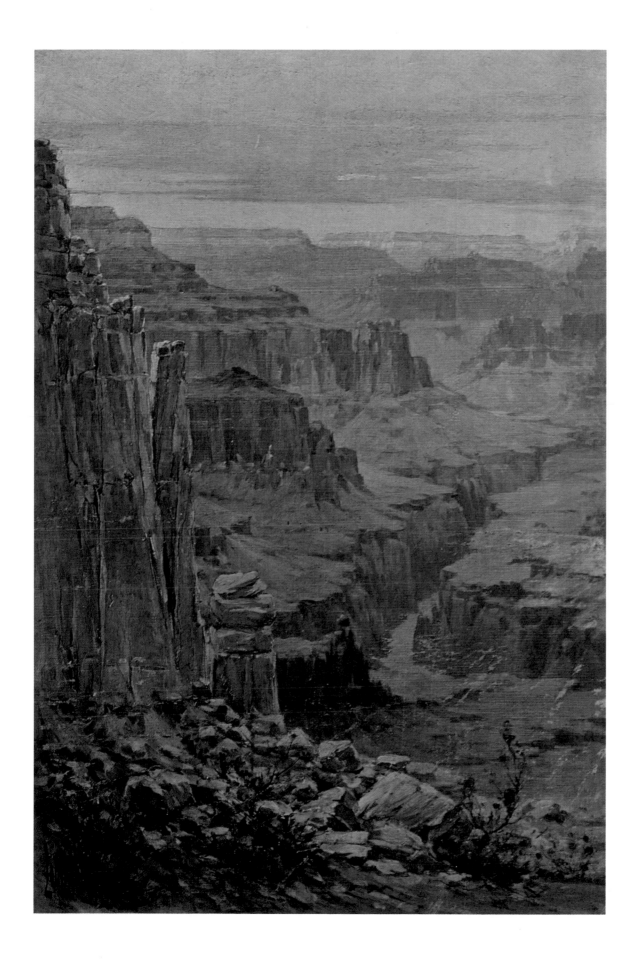

after accumulated debts were paid. Flynn gently refused, and Akin then requested that anything remaining after payment of debts be given to charity. He died five days later on January 3, 1913 and was buried in the Flagstaff cemetery on a gentle slope facing the San Francisco Peaks.

It was left for his friend Tom Flynn to finish up his affairs and notify friends. On January 5th he wrote to Bill Crane:

He has done his last work, his palette and easel, his cases, his blankets and his Indian trinkets are here before me in my big room and as I write; his dog, his constant companion on his trips, is lounging here on his blanketed bed; a picture of himself, contentedly smoking a long pipe, looks down from his clothes closet (the picture done by an artist friend some time ago), but he will know them never again. The magic brush lies there in the case, but the wizard hand now rests forever, and its deft and magic touch is gone. And thus, dear sir, it is. Thus hath Death displaced him from the world that was all too lacking in its estimation of his genius and his worth. My ideas of art are indeed crude, but not so that I could not recognize in our mutual friend a master indeed. Oft have I come and silently watched him as he worked, careful not to unduly disturb him, as that wonderful mind working intensely, strove to make the canvas repeat its picture. Then sinking back in his chair with his longshoreman's pipe sending up wreaths of smoke, he would gaze intently to see what touch was missing, wherein the color blend was not just as he wanted it. If not satisfied, he would plunge in again, working rapidly all the time, until the canvas satisfied him. Then he would relax, forget his art, and read some light magazine for recreation.

A few days later back in New York City his fellow artists at the Salmagundi Club gathered for an evening to pay him tribute "not to eulogize him formally, but to come together once more in a friendly way to think and talk of Louis as they had thought and talked with him so often in the past. The stories of him were good to hear, of his loyalty to his friends, of his devotion to his art."

Acknowledgments

THIS BOOK EVOLVED from a few casual inquiries to finished product largely as a result of the enthusiasm and generous assistance of others. My initial inquiries into Akin's Oregon background were rewarded with the continuing assistance of Mrs. Charles Petheram of Portland. F. A. Tipple, General Advertising Manager of the Santa Fe Railroad, unearthed a file of correspondence between his predecessor, W. H. Simpson, and Akin that provided a wealth of new information about the artist's life in Arizona. The Santa Fe letters in turn led to the Akin-Stanton correspondence preserved in the Robert Brewster Stanton Papers at the New York Public Library. The staff of the National Archives and David Brugge, curator of the Hubbell Trading Post, searched out Akin letters that likewise provided important new details of Akin's life.

Several people shared with me their personal recollections, stretching back almost 60 years, of the artist, including Emery Kolb, Don Talayesva, Henry Albers, Catherine Verkamp, Earle Forrest, Edward Brown, James Swinnerton, Courtenay Monson, and Robert Chambers. A number of individuals generously provided photographs and other Akin memorabilia: George Babbitt, Jr., Michael and Margaret Purcell, Merrill Bittner, Mrs. Herbert Babbitt, Dr. Nathaniel Warner, and Dr. Harold Colton.

Thomas Gallatin, Mrs. Dorothy Hubbell, Wilmer Roberts, Mrs. Francis Crable, Jack Verkamp, Mrs. Kenneth Moores, Mr. and Mrs. William L. White, Richard Anderson, Philip Curtis, George Getz, Jr., Lew Davis, Edith Lehnert, Dwight L. Smith, Mary Moore Ziegler, Helen Shackelford, Aaron Cohen, Doris Dubose, Paul Sweitzer, and Alva Aitken provided more than routine assistance in answering inquiries and directing me to sources of information. Arthur H. Clark generously obtained the consent of the Los Angeles Westerners for use of the copyrighted material quoted in Chapter Four.

I am indebted to the staff personnel of numerous institutions for their help,

including Dr. Edward Danson, Barton Wright and Katherine Bartlett, Museum of Northern Arizona; R. Harmer Smith, The Salmagundi Club; R. A. Clinchy, The Campfire Club of America; Peter Hassrick, Amon Carter Museum of Western Art; John Dewar, Los Angeles County Museum of Natural History; Elizabeth Anne Johnson, Library Association of Portland; and Bert Fireman, the Arizona Historical Foundation. Staff members of Northern Arizona University Library, Grand Canyon National Park, the Arizona State Library and Archives, Sharlot Hall Museum, the Arizona Historical Society, and the Pennsylvania Academy of Fine Arts also provided assistance.

Clay Lockett first suggested that the manuscript deserved publication in book form and generously drew upon his personal recollections of the artist to contribute the foreword to this book. The late Jon Hopkins and Diana Creighton provided much needed editorial assistance. I owe a special debt to my father, Paul Babbitt, who first inspired me to look deeply into the Arizona landscape. My wife, Hattie, provided the continuing assistance and encouragement necessary to sustain an amateur historian on a first adventure into the past. About a year ago when the project was stalled in a maze of frustrating details, she came up with the following observation from Winston Churchill:

> Writing a book is an adventure; to begin with it is a toy, then an amusement, then it becomes a mistress, and then it becomes a master, and then it becomes a tyrant, and the last phase is that just as you are about to be reconciled to your servitude you kill the monster and strew him about to the public.

Chronology

1909 Publication of illustrated essay, "Unexplored Beauty in The Canadian Rockies" in *Craftsman*.

1909 Travels to Glacier National Park.

1910 *Afterglow — Grand Canyon* exhibited at 85th Annual Exhibition of National Academy of Design.

1910 Obtains American Museum commission to paint murals for Hall of the Southwest Indian.

1912 Travels to Hopi villages, Canyon de Chelly and Zuni Pueblo making sketches for the American Museum project.

1913 Akin dies at Flagstaff on January 3.

Selected Bibliography

Akin, Louis. "Frederick Monsen of the Desert — The Man Who Began Eighteen Years Ago to Live and Record the Life of Hopiland." *Craftsman* 11 (March 1907): 678–682.

———. "Hopi Indians — Gentle Folk: A People Without Need of Courts, Jails or Asylums." *Craftsman* 10 (June 1906): 314–329.

———. "Tantalus in Town." *Harper's Weekly*, August 17, 1901, p. 815.

———. "Unexplored Beauty in the Canadian Rockies." *Craftsman* 17 (December 1909): 311–315.

Chicago. Santa Fe Railway. W. H. Simpson Papers, Akin correspondence file, 1907–1913.

Flagstaff Coconino Sun, August 15, 1907; July 19, 1912; January 10, 1913.

Flagstaff, Arizona. Coconino County Recorder's Office. Probate Files, Estate of Louis Akin, 1913.

Flagstaff, Arizona. Museum of Northern Arizona. Martin Buggeln papers, letter dated November 11, 1905, from W. H. Simpson to Buggeln.

Flagstaff, Arizona. Museum of Northern Arizona. Letters from Louis Akin to Robert L. Warner and letter from Thomas Flynn to W. B. Crane.

Forrest, Earle R. *Arizona's Dark and Bloody Ground.* Caldwell, Idaho: Caxton Printers, 1950.

———. "Louis Akin — Artist of Old Arizona." *The Westerners Brand Book, Los Angeles Corral*, Book 6 (1956), pp. 30–47.

———. *The Snake Dance of the Hopi Indians.* Los Angeles: Westernlore Press, 1961.

Ganado, Arizona. Hubbel Trading Post, National Historical Site. Letter from Louis Akin to Lorenzo Hubbel dated July 31, 1911.

Hough, Walter. *The Moki Snake Dance*. Chicago: Santa Fe Railway, 1898.

Huckel, J. F. *First Families of the Southwest*. Kansas City: Fred Harvey, ca. 1912, and later editions.

"Louis Akin, Painter: In Memory." *Craftsman* 23 (March 1913): 676–679.

MacDonald, George. "The Indian Pictures of Louis Akin." *Brush and Pencil*, September 1906, pp. 113–116.

New York. New York Public Library. Robert Brewster Stanton papers, 1907-1908.

New York Times, April 23, 1905.

New York. Two unidentified New York newspaper reviews of Clausen Exhibit dated April 23, 1905.

Parker, Charles Franklin. "Sojourn in Hopiland." *Arizona Highways* 19 (May 1943): 10–13, 41–43.

Phoenix Arizona Republican, November 11, 1911; January 5, 1913.

Portland Journal, January 13, 1913.

Portland Oregonian, October 25, 1908; January 12, 1913; March 15, 1922.

Santa Fe Railway. *The Grand Canyon of Arizona*. Chicago: Santa Fe Railway, 1906.

Warner, Robert L. "Louis Akin — Nature Lover." *Forest and Stream*, February 22, 1913, pp. 231–232.

———. "Louis Akin, American Artist." *Natural History*, 1913, pp. 112–117.

Washington, D. C. The National Archives. Record Group No. 75, letter from Louis Akin to Francis H. Leupp, dated February 7, 1905.